THE MYSTERIOUS MISS EMPRESS

Hollywood's Forgotten Film Vampire

SAMUEL FORT

Nisirtu Publishing

ALSO BY SAMUEL FORT

Cult of the Great Eleven

A detailed, true account of one of Los Angeles's most mysterious cults - the 1920s Divine Order of the Royal Arms of the Great Eleven.

Weird Wires

Weird Wires 2

Creepy Nebraska

The Apocalypse Script

The Ardoon King

Eldritch Puzzles of Unspeakable Madness

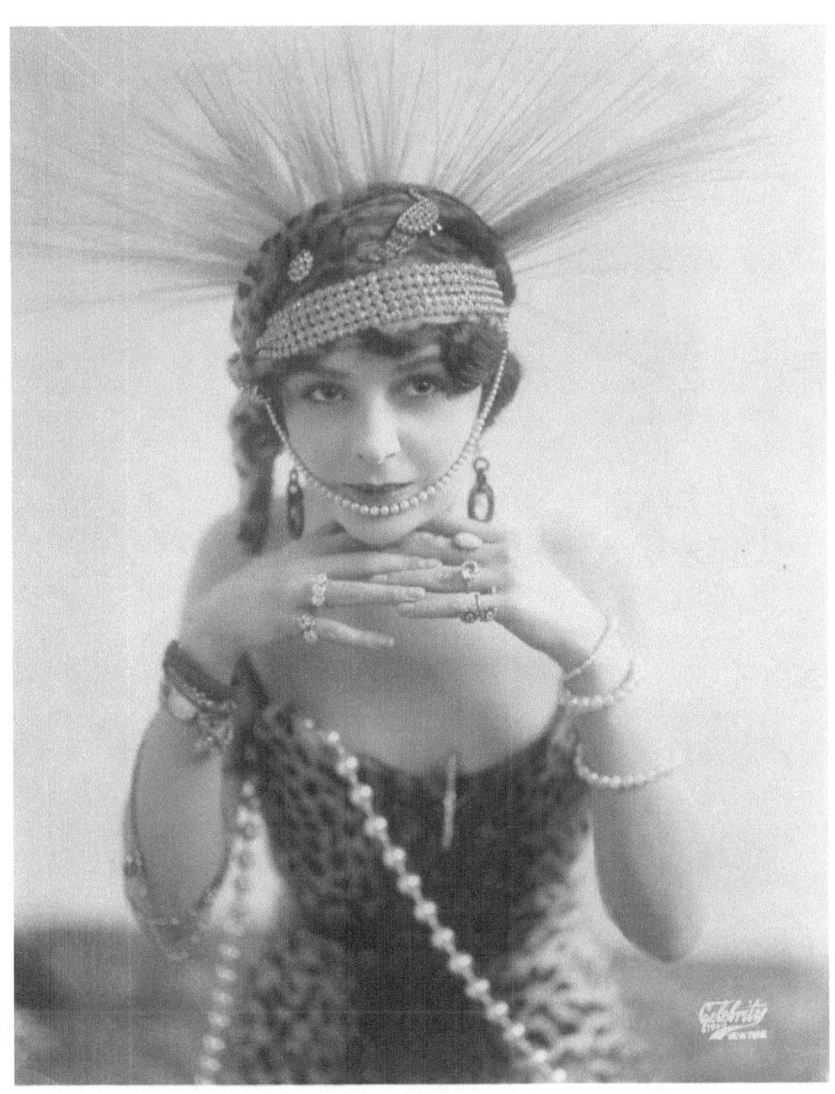

Dedicated to the Sublime Vampire

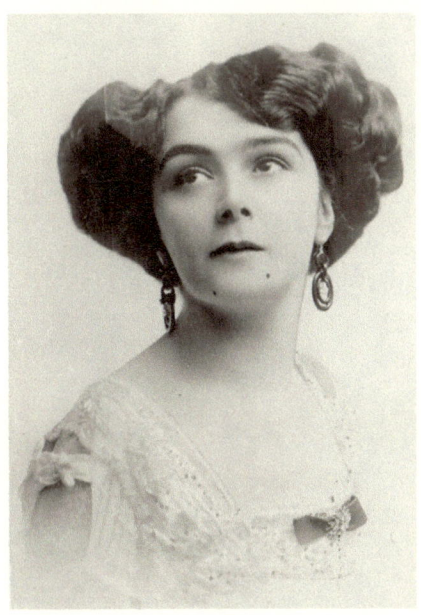

Miss Marie Empress (photo circa 1915)

CONTENTS

Preface	xi
1. Vaudeville (1907-1910)	1
2. The Folies Bergere (1911)	12
3. A Year of Solitude and Tragedy (1912)	20
4. The Legitimate Theater (1913-1914)	25
5. The Vampire (1915)	29
6. Mistress of Disguises (1915)	40
7. The Grip of Evil (1916)	47
8. A Pro-Bono Performance	54
9. A Prolific Year	58
10. Damn the Torpedoes	64
11. The Girl Who Doesn't Know (1917)	68
12. The Halifax Journey (1919)	77
13. Now You See Her...	81
14. ...Now You Don't	86
15. The Mystery of Stateroom 480	89
16. Hot, Thin Air	95
17. Hoax?	99
18. A Thief In the Night	102
19. A Pretender To The Throne	107
20. Miss X	113
21. Family and Friends in High Places	116
22. Ship Manifests	122
23. Unusual Contacts	126
24. Miss Nobody	130
25. The Curtain Lifted	134
Afterword	139
Marie Empress Film Chronology	141

PREFACE

The Queen to her slave, Pharon: "If I let you live - - and love me - - ten days, will you swear then to destroy yourself?"

– Scene from the 1912 silent film *Cleopatra*

Marie Empress was considered one of the most beautiful women in the world during the second decade of the 20th century, and for a short period, her star was very bright.

Today she is forgotten. Her name is sometimes granted a spot in a collection of movie star biographies, but when it is, the information is sparse and often erroneous. Empress did not achieve the fame of contemporaries Theda Bara or Mary Pickford, but she merits more than obscurity. The talented Englishwoman's ambitions were just as magnificent as any other performer of her day. A woman of seemingly inexhaustible energy, she experienced the same highs and lows of most other vaudevillians and film stars. She was praised, ridiculed, booed, adored, ignored, and coveted.

Empress was amazingly versatile. She was a singer, dancer, actress, writer, and comedian (or *comedienne*, in the parlance of her era). She was also a gifted male impersonator. It was said she could walk the streets

of New York as a man without raising an eyebrow. Empress was acknowledged to be a genuine master of disguise, capable assuming the role of any person of any sex, age or nationality.

It is perhaps only a modest exaggeration to say she was the female counterpart to Lon Chaney, though Empress's career was ending just as Chaney's was gaining speed. Whether her acting talents matched her skills at disguise, as was the case with Chaney, cannot be known, as all her films are presumed lost. But it could be argued that Empress was, in a sense, more dedicated to her art of deception. Chaney was himself when he was not playing a role in a film. The same cannot be said of the woman who called herself Marie Empress.

Her sudden appearance on the world stage in 1910 was almost as inexplicable as her mysterious vanishment just a decade later. She claimed many names and many histories, public and private. It appears none were real. Beneath every mask was yet another mask.

Indeed, her friends and family are as unknowable today as they were a century ago. She was simultaneously single and married. She had four or more maiden names. She was born in France, and in England, and in the United States, on different years. She never once provided the name of a family member as a point of contact on a ship's manifest, despite having crossed the Atlantic more than a dozen times, often with the stated objective of visiting them.

There were suspicions that she was connected to the British aristocracy, or perhaps the Rothschild family, and that her unceasing obfuscations were an attempt to conceal her pedigree.

Empress was so gifted at fooling the public that when she mysteriously disappeared in 1919, her fans and reporters assumed she was playing a hoax. When officials opined that she'd probably died at sea, the public dismissed the idea. It was, they noted, a very odd demise, the kind where death is proclaimed in the absence of a body; the kind where events leading up to the event and following it are so markedly *peculiar* that death seemed too conventional an explanation.

Everyone who knew Empress assumed she would magically reappear someday. Long after she was last seen in public, newspapers continued to proclaim the inevitable, imminent reappearance of the

allegedly dead woman. She was to be a self-made Lazarus, arising from her watery tomb.

A year after she disappeared, the decade that would become known as the "roaring 20s" arrived, and with it, the golden era of silent film. Movies and the movie-going experience would improve dramatically during this decade. Hollywood studios would begin producing films at a prodigious rate, using filming techniques and equipment that was far superior to anything used during Empress's era. The films in which Empress and others starred during film's formative years seemed crude in comparison and were largely neglected.

At the same time, survivors of the Great War were rebuilding their world and trying to forget the terrible years of conflict that coincided, unfortunately, with Empress's film career. Ragtime faded, and jazz reached new heights. Flappers dressed and behaved in a manner that made the once-daring fashions and attitudes of "vamps" like Marie Empress and Theda Bara seem almost pedestrian.

The world, in short, moved on. By the time any rational person would agree that Marie Empress was *not* returning, it did not matter. It was too late for newspapers to bother with obituaries or articles that might capture for posterity her achievements on stage and film. In the following decades, all of her films would be lost or destroyed, and her name forgotten. If Marie Empress did indeed intend to disappear, she was spectacularly successful, for she disappeared not only from her stateroom at sea, but also from the public imagination, and then, largely, from film history.

This small book is an attempt to reintroduce film lovers to the odd life and odder death of someone who perhaps never existed: Marie Empress.

S.F.

I

VAUDEVILLE (1907-1910)

> Perhaps you have talents to take you
> To heights of exceptional fame
> Perhaps your ambition will make you
> A great and illustrious name
> I can't say what you'll become later
> But one thing I certainly know
> You'll never be a good waiter
> So take off your apron and go!
>
> — LYRICS FROM *THE LITTLE CAFE* (1913)

Though it is unknown at what age she began her career as an entertainer, the woman who is best known as Marie Empress was performing in South Africa in 1907. While modern readers might imagine such a destination as remote and primitive at the turn of the 20th century, South Africa was a popular venue for American and European entertainers. South Africa was a British Colony and the subjects there were just as willing as the subjects in London to pay good money for some song and dance. Of note, Will Rogers, Nance O'Neil, Walter C. Kelly, Geraldine Valliere, W.C. Fields,

Marie Lloyd, and the Doherty Sisters all made stops in South Africa during their world tours.

On September 7, 1907, Empress traveled to Cape Town from Southampton aboard the *Kenilworth Castle*. She returned in December 1907 aboard the *Carisbrook Castle*, accompanied by four music hall artists - the three-member Martine family and a Mr. Trovollo; and two "artistes" - Miss T. da Silva and Mr. Muller. Only Empress used the professional title of "actress."

By 1908, Empress had returned to England. Her name appears on several 1908 rosters, including those of the Hackney Empire Theatre (June) and the Sunderland Empire Theatre (August). At the Hackney, which offered two shows per night, one at 6:45 p.m. and another at 9:00 p.m., she shared the stage with the Tenji Troupe, Phil and Nettie Peters, Mabel Bardine, Jack Pleasants, the Four Jummels, George Rigewell, Mike Nono, and Herbert Sheley. At the Sunderland she performed alongside the Gothams, Johnson & Bert, Maud Rochez, Wilson & Waring, Harry Marte, Carl Howard and Dunedin Troupe.

A decade later, the *London Times* acknowledged that the young woman "was well known in London as a vaudeville and film actress."

In 1909 or 1910, an American by the name of Henry Benjamin Harris approached Empress and asked if she would be interested in traveling to the United States and performing in one of the theaters he managed. A manager, promoter, publicist, agent, and theater owner, Harris was one of the most prominent figures in American theater of the era. He owned or had an interest in theaters Chicago, New York City, Philadelphia, and Syracuse, and managed (among others) May Irwin, Peter Dailey, Lily Langtry, Amelia Bingham, and Robert Edeson.

Harris wanted Empress to appear at his Young' Pier Theater, in Atlantic City, which offered, according to the *Washington Post*, "the best vaudeville available at the shore." It hosted celebrities such as Annie Oakley and Will Rogers and was the home of "high-end" vaudeville. While there were plenty of small-town vaudeville venues for struggling performers of questionable talent, vaudeville theaters in larger cities sought to satisfy the recreational needs of the middle and upper

classes, recruiting the best and most established entertainers for those who could afford premium ticket prices.

In a 1911 example, the *New York Times* reported that Ben Harris had offered singer Adelina Patti $15,000 *a week* if she would agree to two performances a night. This was at a time when the average American could expect to earn $15 a week. Successful theaters made their owners rich. Ben Harris was a millionaire many times over.

Because this brand of vaudeville was so profitable, there was keen competition for the best performers. Ben Harris and his peers, to include Henry Savage and C.B. Dillingham, traveled to London each spring to scout out and sign English talent and to obtain the rights to British plays. The *New York Times* dubbed this "the annual American theatrical invasion of London."

It was during his 1909 scouting expedition that Harris had come across Marie Empress and offered her work in the United States. She agreed, and Ben Harris wasted no time in initiating a media blitz to promote his new young performer's arrival. As a *New York Times* columnist observed prior to the Englishwoman's first performance, Marie Empress's arrival in America was "much advertised."

An example is this is a *New York Sun* boxed advertisement:

Bulletin No. 3

Beware of Imitations. This is authentic and the only authorized announcement. O. K. J. Muller for Marie Empress.

ARRIVED yesterday.

My mission has already been told, and I am very much in earnest. The ambition of my life has been to appear in New York but I have always been dreadfully afraid of failure in a foreign country. Outside of England I have been fortunate in appealing to the theatergoers of South Africa and Australia. BUT. AMERICA—that is the ambition of all. Still. I have been told that your audiences are most exacting and discerning, and while I thank the managers for their offers. I was anxious to just see for myself. I am, cordially. Marie Empress (signature). The Gregorian.

"Announcement was made yesterday," reported the November 7, 1910 issue of the *New York Tribune*:

> ...that Marie Empress, English comedienne, will appear shortly in vaudeville in this city. The actress came over to this country undecided as to whether to take the plunge into American vaudeville or not. Having looked the field over, she has decided in the affirmative. Her representatives lay great stress upon her wearing apparel and songs.

A week later, the *Sun* reported:

> Marie Empress, the English singing comedienne who came to America last week to see for herself what the vaudeville audiences here are like before agreeing to sign a contract, has been engaged by Ben Harris, the manager of Young's Pier, Atlantic City, to appear at his theater next week. She says she has found the audiences here different from what she had been lead to think.

Ben Harris stressed the new performer's physical charisma. Though by most accounts a diminutive woman, Empress was strikingly attractive. Her black hair was long and lush, and her brown eyes were large, bright, and daring. Some newspapers reported that she had Italian ancestry, and indeed, ship manifests reported her as having a medium to dark complexion.

She was sometimes mistaken for Lina Cavalieri, a then-famous Italian operatic soprano whom many held to be the most beautiful woman in the world. The title of a 1955 film about Cavalieri's life was *The World's Most Beautiful Woman*.

Empress was also a woman who appreciated beautiful clothes and large shiny rocks set in precious metals. She would establish a reputation for wearing jewelry that cost more than the in which productions she starred.

Ben Harris was not relying on his client's good looks alone to attract theatergoers. "Marie Empress," he told the *Music Trade Review*, "has in her repertoire of songs an unpublished ballad by Gilbert and Sullivan, entitled 'Other Days.' She will also sing Feist songs... Her

agent announces Miss Empress will pay $1,000 to the composer furnishing her with the most suitable new song, this to be hers exclusively and to remain unpublished."

Not every claim made by theater men such as Ben Harris about their performers was true. Agents and publicists then, as today, were unapologetic about the lies or exaggerations they propagated to sell tickets, and audiences expected, even desired, a certain amount of fictional spice.

So it is somewhat surprising that the Harris may have been telling the *Trade Review* the truth. In 1943, Chappelle & Company, Ltd., London, published sheet music for a song titled *Other Days*. It does not appear to have been published previously. The words for the song were by penned by Harry Graham and the music was, in fact, written by Arthur Sullivan, of Gilbert and Sullivan. It must be more than mere coincidence that Arthur Sullivan wrote a song he titled *Other Days* and that Marie Empress claimed to have a song by that very name in 1910 which she claimed was written by Gilbert and (Graham) Sullivan.

The promise that Marie Empress would pay a thousand dollars for an original song may have been equally genuine. In December of 1910, she copyrighted two original compositions: *Why Did I Marry Mr. Brown?*, with words by John Harrington and music by John Tate, and *Eyes*, with lyrics by Douglas Hoare and music by Edward Jones.

Harris's publicity campaign was so pervasive that other theater owners sought to take advantage of it, falsely claiming that Empress was also scheduled to appear in *their* venues. *Variety* reported this fraud:

CLEVER PUBLICITY.

Clever publicity, in method and matter, preceded the disclosure of the name of Marie Empress as the person advertised, during the week.

Monday the daily papers had advertisements in the amusement columns, marked in no way for identification, carrying but a cut of a crown.

They mentioned that an English artiste was coming to New York, deciding after seeing the city and its vaudeville theatres whether she

would appear over here. Wednesday the artiste, who is Marie Empress, an Englishwoman, arrived on a Cunard liner.

The advertisements were run in three sets, the copy being distributed among all the morning and evening dailies. Before the first publication none of the show people knew who was being exploited, but the booming attracted much attention.

Mark A. Luescher and Leo Donnelly were behind the publicity pushing. Miss Empress may appear in a New York house shortly. Immediately after the first publication of the advertisements, a New York theatrical manager attempted to make capital of the publicity through an announcement sent to the dailies as part of his house advertisement that "Miss Empress" would appear there next week.

The anonymous notice was protected however through J. P. Muller & Co., the advertising agents, and the papers, when informed the "follow up" was not genuine, declined it.

SADLY, THERE ARE NO REMAINING REVIEWS OF EMPRESS'S performances at Young's Pier Theater. Presumably, her performance was well received, since her next engagement was at the larger and more established Hammerstein Victoria Theater in New York. It was announced in the November 27, 1910 edition of the *New York Times* in the Vaudeville section:

> At Hammerstein's Victoria Theatre the bill will be headed by Marie Empress, making her first appearance in New York.

Others on the bill included the "Silhouette Girl" (a dancer from Paris who performed behind an illuminated screen), the comedienne Lillian Shaw, and numerous sketch comedy players.

The Victoria, on 42nd and Broadway, was the most successful variety theater in New York, bringing in millions of dollars a year. Unfortunately for Empress, the Victoria was also exactly the kind of venue that her peers back in England had warned her about when trying to discourage her from going to the United States. While it was

a major and extraordinarily profitable theater in which many notable celebrities performed, to include Will Rogers, Houdini, and Mae West, it was better known for its sensational acts, controversial performers, and rowdy audiences.

The theater was managed by Willie Hammerstein, the son of Oscar Hammerstein. Willie was a pioneer in the art of selling outrage and exploitation as entertainment. His performers included the likes of Jack Johnson, a black boxer who was known to have dated white women (recall this was the first decade of the 20th century), the Cherry Sisters (America's "worst singers"), Evelin Nesbit, suffragettes, and a variety of notorious if untalented guests best known for their sex scandals, crimes, and provocative beliefs.

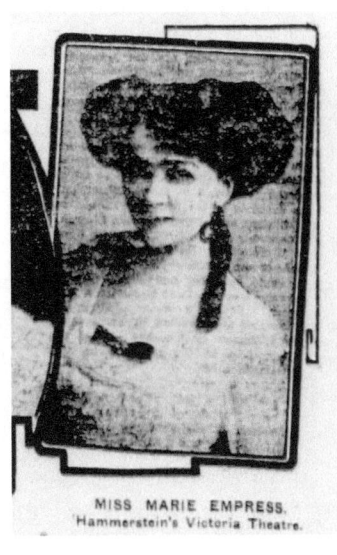

MISS MARIE EMPRESS.
Hammerstein's Victoria Theatre.

In short, Willie Hammerstein would do anything to keep New Yorkers talking about and patronizing the Victoria. This even included mock executions. Tellingly, the crowds booed when the criminals to be executed were pardoned at the last minute.

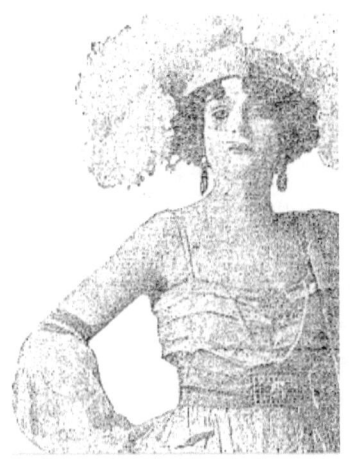

Had Empress been made aware of the Victoria's reputation, she might have elected not to perform there, or, alternatively, she would have performed and given the kind of show Willie Hammerstein loved, knowing full well that the boos and catcalls were part of the package at the Victoria. Not knowing, Empress entered the lion's den completely unprepared.

Empress's first performance at the Victoria occurred on November 28.

Unfortunately for her, the over-the-top promotions raised expectations to unattainable levels.

As reported in *Variety*:

> Marie Empress was the centre of a rather curious experiment when appearing at Hammerstein's Monday for her first New York showing, and the young woman's second public week on this side of the ocean. She has been heralded as an English favorite of the halls. As far as information goes, Miss Empress is not widely known in her native land. But she had, for her American debut, the benefit of as clever publicity as was ever received by an unknown. It was started and kept up, eventually bringing a singer (previous to the first advertisement in her behalf never heard of in New York) to the headline position in one of the country's biggest vaudeville theatres.
>
> The expert direction did not end with the publicity. The showmanship extended to her stage appearance. Miss Empress had her own orchestra leader, a plush curtain marked "M. E.;" opened in "two" before going into "one" with an ordinary olio drop; then back to "two" and the curtain for her third and last song, with a choice program position to do it in.
>
> After the final number, a cartload of flowers paraded down the aisle. Friends and well wishers extended to Miss Empress a cordial greeting in the way of applause, obliging bows and a little speech of thanks - but after all that, and meanwhile, Miss Empress cannot uphold the position made for her. Nothing had been left undone. A great opportunity had been provided - and lost. The benefits of advertising and publicity had been strikingly illustrated. Not too much was looked for after cleverly worded advertisements had carefully set forth Miss Empress' position - that of ascertaining whether she would succeed before an American audience.
>
> These notifications really absolve the girl from criticism. Even the program says "Only Appearance in America—One Week Only." The English girl is a pretty brunette, wearing two gowns and one character costume. Of the three songs sung, Miss Empress displayed no marked ability in either. "Lingerie," the third selection, was depended upon, but Miss Empress lacks that which is necessary to become a success as

a single act on the big time over here. 'Tis the well-known theory - publicity can't make an act in vaudeville, but it will do a lot if the act is there to back it up."

"Marie Empress is not there," the reviewer concluded.

The *New York Times* opted to practically dismiss the performance, reporting merely that "Marie Empress, a heavily advertised English performer...made her appearance at the Victoria," and, elsewhere, that, "Marie Empress (Hammerstein's) wore a very handsome dress of white satin, made very tight and with a long train."

The show went so badly that many assumed Empress's performance at the Hammerstein was destined to be her last. *Variety* reported that one of the performer's patrons asked how much Empress would sell the ornate curtains that bore her initials. Indignant, Empress sent the potential customer away empty-handed.

Still, Empress was shocked and humiliated by the Victoria's unappreciative patrons, and lamented to her friends, "America is savage. I can never conquer it!"

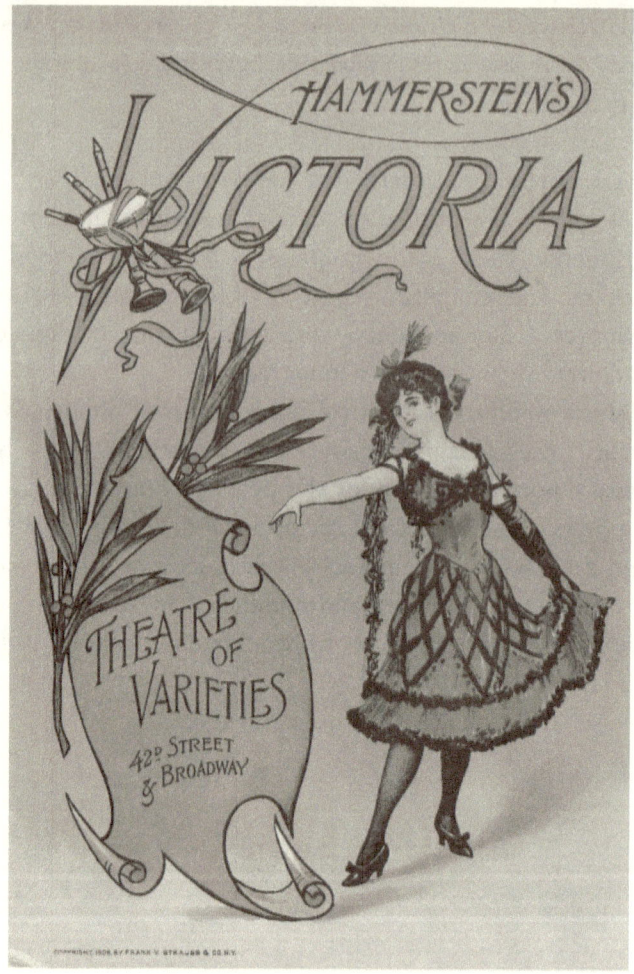

Program Cover, Hammerstein's Victoria (1906)

Refreshments List, Hammerstein's Victoria (1906)

2

THE FOLIES BERGERE (1911)

> Why do they rave about beautiful France
> Where the wine flows and the maidens entrance?
> Why go to Berlin, Vienna or Rome?
> We can enjoy all their joys here at home -
> In old New York up at Long Acre Square!
> Turn 'round the corner, you'll find yourself there
> Millions of miles from all trouble and care
> Two doors from Heaven - the *Folies Bergere!*
>
> — LYRICS FROM *DOWN TO THE FOLIES BERGERE,*
> BY IRVIN BERLIN (1911)

Empress returned to England following the Victoria debacle, but her flight was brief. On January 25, 1911, she boarded the *S.S. St Paul* in South Hampton and again sailed for New York. Neither Empress nor any of the other five First Class passengers were required to provide much information for the ship's log. Columns 6 through 29, which covered such topics as *Height, Deformities, By whom passage was paid,* etc., are blank, with one exception. Beneath column

THE MYSTERIOUS MISS EMPRESS

18, "Whether going to join a relative or friend; and if so, what relative and friend, and his name and complete address," there appears the word "Tour." All persons were listed as U.S. citizens - to include Empress.

Handwritten on side of the manifest, under destination, is "1931, 19th [or 17th - writing is unclear] Street, Washington." The latter is a home built in 1908 referred to as "The Wilton." The house on 19th street is 3,420 square foot home built in 1909 that is just a few blocks from the Cathedral of St. Mathew.

Other First Class passengers included: Mrs. Marsh Hoffman, 65, Miss Hillary Zehnder, 28, Mr. Thomas H. Kilduff, 48, Mr. Charles P. Norcross, 36, and his wife, Mrs. Mildred Norcross, 35.

Mr. Norcross was an editor for *Cosmopolitan Magazine* and had been in England pursuing the American rights to a claimed English cure for tuberculosis - that was his story, at least. Unfortunately, he had borrowed $18,000.00 for an initial investment from New York City Chamberlain Charles H. Hyde, who had illegally appropriated the funds from the Carnegie Trust.

Hillary M. Zehnder was from Scranton, Pennsylvania, and daughter of W.D. Zehnder, founder of the hugely profitable Scranton Bolt & Nut Company. She attended Yale from 1901-1903, studying medicine.

Thomas H. Kilduff was a member of the New York Chamber of Commerce. Interestingly, he had been nominated as a candidate to the Chamber in 1907 in absentia, being then in Florence Italy. His wife was a descendant of the late Honorable Albert G. Riddle, who died in 1902.

※

AFTER THE WASHINGTON D.C. VISIT WAS COMPLETE, EMPRESS IS reported to have retired for two years to Amityville, Long Beach with an unidentified "rich husband." During this period, Empress could be found in only one of two places – vaudeville theaters, as an audience member, and dog shows, as a competitor.

Empress *loved* dogs, particularly miniature versions, and she

competed in numerous New York area dog shows. Two of her most successful canines were "Ashton Sheila" and brother "Ashton Adonis." Both were famous - in the dog show universe, at least - as soon as they were born in the Ashton Kennels in Britain in 1908. Sheila's original owner, from whom Empress presumably obtained her, was a Mrs. A.M. Raymond-Mallock, formerly Lillian C. Moeran, one of the foremost breeders of miniature dogs in the world at the time. In 1911, Ashton Sheila, then Empress's, was awarded prizes by the Westminster Kennel Club, the Long Island Kennel Club, the Plainsfield Kennel Club, and the Toy Spaniel Club of New York.

The Toy Spaniel Club dog show was held in December at the Waldorf-Astoria Hotel (the two buildings that formed that hotel at that time, the Waldorf and the Astoria, would be demolished in 1929 to facilitate construction of the Empire State Building). The Waldorf's competition was serious business - the New York Times boasted that the pet owners present were the "aristocrats of toy dogdom."

"Empress Mite," another of the young Englishwoman's pets, also won a prize at the Waldorf that year. Mite had previously won first place at the Plainfield Kennel Club's dog show in New Jersey and was soon to take home first prize in the "Black and Tan" category at the Nassau County Kennel Club competition in Belmont Park.

WHILE EMPRESS WAS MOMENTARILY CONTENT VISITING THEATERS and competing dogs, Ben Harris, her manager, was busy trying to expand his entertainment empire. In 1911, he partnered with another famous theater and vaudeville power player, Jessie L. Lasky, to open a sophisticated, high-class cabaret on 46th Street. He called it the *Folies Bergere*, shamelessly borrowing the name of a much more famous Parisian club of the era.

Offering top-notch entertainment, food, and drink, the Folies was a venue for the discerning and demanding patrons of means. The theater, which *Variety* called, "a burly (burlesque) show of the highest type" and which the *New York Times* called, "more Parisian than Paris" was celebrated in the Irvin Berlin song *Down To The Folies Bergere:*

*Why do they rave about beautiful France
Where the wine flows and the maidens entrance
Why go to Berlin, Vienna or Rome
We can enjoy all their joys here at home
In old New York up at Long Acre Square
Turn 'round the corner, you'll find yourself there
Millions of miles from all trouble and care
Two doors from Heaven the Folies Bergere!*

*Down, down, down, down, down to the Folies Bergere
Order a Taxi, a cab or a car
Go where the girlies sing oo la, la
Girls, boys, joys, noise, laughter and music all there
Ask me where? Where? Where?
Down to the Folies Bergere!*

*Why do they sing of the Rathskeller's joys
Who go to places just meant for the boys
We'll get the girls and we'll bring them along
Down to the folies, they'll see nothing wrong
Bring down your sweetheart and give her a seat
If your wife's there get a gallery seat
Then if your wife and your sweetheart should meet
Thirty-two exits lead out to the street!*

As the *Times* reported at its grand opening:

The Folies Bergere cannot be treated as an ordinary entertainment or an ordinary playhouse. The combination of music and spectacle and food and drink is something unusual even here. To begin with, there are tables instead of chairs, and there are two separate sets of musicians to play during the dinner hour, which is supposed to begin at 6:30, and began last night at something after 7, because the diners did not arrive in time. One group of players, a Hungarian orchestra, is located on the stage, and the other, a string quarter, is in the rear of the main floor.

At half past eight...the performance on the stage proper began. The first of this was a 'profane burlesque' in one act, entitled, 'Hell' and written by Rennold Wolfe, with music by Maurice Levi. It hadn't any discoverable plot, but it had sufficient satirical features to keep the audience thoroughly amused.

The play started with Ada Lewis imitating Maude Adams, reciting the prologue to 'Chantecler', a French play most notable because all the characters are barnyard animals.

After that, the Statue of Liberty spoke, though at some point the woman portraying her transformed into the wife of the Devil. "Newcomers to the Satanic realms arrived by means of a mail chute," reported the *Times,* "or through the boiler plate doors of an elevator." The Devil was played by Otis Harlan.

Another performer in the Hell skit was the notorious Aimee Gouraud (better known by her maiden name, Aimee Crocker), who appeared simply as herself. Indeed, no one could ask Gouraud to do more, as she was already bigger than life. Born into millions of dollars, the eccentric had spent her life traveling the world and living a life of excess that is hard to comprehend even today.

She had been engaged to the German Prince, Saxe Weimar, and a Spanish bullfighter before marrying, though that marriage ended when both she and her spouse ruined it with multiple affairs. She then traveled to the Far East, where her many adventures included encounters with headhunters in Borneo and three weeks service in a harem. When she returned to the States, she was covered in tattoos and attended parties wearing snakes around her neck.

Years later, as reported by *Green Book Magazine*, Ren Wolf admitted he had doubts about *Hell*. After the first showing, Channing Pollock, who had helped Wolfe write the play, and who would years later work as the American editor of the German film *Metropolis*, asked Wolfe, "If this were another man's work, and you were writing a criticism of it, what would you say?"

"Rotten! What would you say?"

"Same thing."

THE MYSTERIOUS MISS EMPRESS

Pollock then relates how the two men expected to be summoned by Lasky and Harris the next morning. When no summons came, they hunted down the two managers, and asked what should be done about the piece.

"Do?" came the reply, "Nothing! It's all right!"

<center>❦</center>

OTHER ACTS THAT NIGHT INCLUDED:

- an elaborate march number by young women in shining armor bearing lances and swords
- a chorus of young women representing various forms of femininity
- a march by young women bearing signs for each of the states in the union
- Kathleen Clifford (singer)
- Mlle. Lenclud (dancer)
- a 40-girl ballet called "Temptation"
- a three-part revue called "Gaby" (music composed by Irvin Berlin),
- "Primas" Borghini and Britta (dancers)
- a midnight cabaret

The reporter for the *Times* was so overwhelmed that he lamented, "To attempt to describe the wealth of novelties the audience discovered would take several columns of space."

Nevertheless, he did describe those aspects that he thought most intriguing. Among them were the "emergency" buttons installed at each table, which, when pushed, brought a glowing red orb to the top of a silver column installed in the center of the table. The appearance of the red globe resulted in the immediate appearance of a theater attendant who would provide whatever was needed, whether cigar, wine, or *other*.

There was also a mechanically controlled retractable floor – an

amazing feat for 1911. When dinner came, the floor would slide over the orchestra pit, so that as the orchestra continued to play, performers could dance adjacent to the dining customers. Valets, maids, hairdressers, and manicurists were available in the restrooms.

Two of the most notable of the Folies performers, from a historical perspective, were Mae West, who had also performed at Hammerstein's Victoria, and Ina Claire. West appeared in the show *A la Broadway*, which premiered on September 22, 1911. Ina Claire would go on to be a silent and sound motion picture star.

Marie Empress may have appeared at the Folies under another name. Years later, newspapers and magazines would report that Empress had performed at the Folies Bergere in Paris. However, there is no record of Empress having traveled to Paris, aside from an aborted 1915 trip (she was wired a better offer from the States before she reached France). It is possible, even likely, that reporters confused Harris's New York version of the Folies Bergere with its Parisian counterpart.

Empress's qualifications to work at the Folies were impeccable. She was beautiful; she could sing and dance; and, perhaps most importantly, she was a skilled impersonator. She was fluent in French and frequently elected to sing French songs or portray French characters on stage. In fact, she sometimes listed her place of birth as France on ships' manifests, and once claimed that her mother was the "famous" Mme. Belchere, who Empress's publicists pronounced "the peer of any great French actress."

The Folies hosted what reporters called "French imports." Almost all were women. These included Janette Denarbar, Martha Lenclud, Simone De Beryl, Mlle. Grace La Rue, La Belle Titcomb, and a team of "French eccentric dancers" referred to as "Les Marquards."

But some of the allegedly French performers were, in fact, Americans faking a French accent. The Folies sold fantasy, not reality. One of the Folies' most noted performers, Olga Petrova, "the Russian character comedienne," was, in reality, Muriel Harding, an Englishwoman.

While it is anyone's guess what identity Empress might have assumed, that of Janette Denarbar is as good as any. When interviewed

by a reporter and asked how she liked America, Mlle. Denarbar said, "America ees - vairee, vairee - tres joll."

The "little dancer" later went to the Folies kitchen and prepared the journalist a salad, presenting it to him with the words, "If you please."

Her accent? English.

3

A YEAR OF SOLITUDE AND TRAGEDY (1912)

All day long the sea grew calmer and the air damper, until by evening the "Campania" was plowing through a grey ocean smooth as a pool of melted lard and ringed by the first vapors of the Grand Banks...He turned and saw Helen Langdale not far away, staring at the skyline...

Suddenly the liner had plunged into a fog-bank and grey vapors were wriggling all about them...

"...I'm doped or bewitched or something. All this - it is horrible - a dream!" He waved his arm.

"Granted. But then - why not dream?"

She stepped back and raised her hand to push a curl under the low straw hat. As she stood there gazing at him quite solemnly, Morris heard the pounding of the engines and the hiss of the spray - suddenly, as if complete silence had been broken. For some reason, he felt surprised that Helen was not wearing a veil.

— EXCERPT FROM THE SHORT STORY *THE OCEAN PASSAGE*, YALE LITERARY MAGAZINE (DECEMBER 1912)

THE MYSTERIOUS MISS EMPRESS

By September of 1911, the Folies Bergere had failed. The high-class cabaret had not even survived a year.

It was not that there was no demand for such an establishment. There was, and would continue to be. Harris and his partner, Lasky, were visionaries, and correctly foresaw the future of live entertainment in America.

The most commonly cited reason for the Folies' failure was that given by Jesse Lasky himself: the cabaret, which seated 700 people, was simply too small. Though ticket prices were high for the better seats and profits per customer were excellent, there was no way for the relatively modest venue to seat enough customers to turn a profit, given the costs of top tier entertainment and the theater's overhead.

Lasky lamented, "in order to break even we had to keep the theater in almost continuous operation from noon until early morning with crowds."

That was impossible since the theater was so luxurious that the average New Yorker simply passed it by.

Ticket sales were not helped by the uncommonly warm summer New Yorkers suffered that year. In an era before air conditioning, theaters became ovens during the hot summer months, even in the evenings (thus the popularity of rooftop entertainment). No one would buy a ticket to bake in a theater, no matter how good the acts or how fine the trappings.

The heat had compelled Harris and Lasky to close the Folies for three weeks in July of 1911. Their competitor, Willie Hammerstein, was so desperate to draw in overheated patrons that he displayed a large thermostat outside the Victoria's door that purportedly showed the cool temperatures patrons would enjoy inside. It was secretly nested on a hidden block of ice.

Lack of talent was another reason the endeavor failed so quickly. In *The Stage in the Twentieth Century*, Robert Grau argued that the primary reason for the Folies failure was that the theater lacked "compelling sensational attractions without which the Paris house of the same name would fail."

The failure proved to be a costly one. Harris and Lasky had

invested, and lost, almost $400,000 by the time the Folies closed its doors. That was a staggering amount of money in 1912.

Then, things got worse.

In March of 1912, another of Harris's venues, Young's Pier Theater, where Empress had first performed in America, burned to the ground. The fire, which was probably the result of faulty wiring, began between the double floors of the dressing rooms at the back of the theater and spread rapidly. By the time firemen arrived, the theater had burned to the ground, and the flames had spread to adjacent buildings. Three firemen died when one of the buildings collapsed on them.

Despite these tragedies, Ben Harris trudged forward, making his annual pilgrimage to London in 1912 to recruit new talent. The expedition went badly. According to a report in the *New York Times*:

> Harris has spent several days here, looking for attractions, but is not meeting with much success. He told THE NEW YORK TIMES correspondent that he had never found artists in such an unreceptive mood as now, but expects to get Maud Allen to make the trip.

Maud Allen was an attractive, highly provocative dancer who pushed the sexual envelope to the edge and, for the era, over it. A former pianist, the Canadian-born Allen quit playing the piano and took up what she viewed as the more expressive art of dancing when her brother was hanged for the murder of two women in San Francisco. She spent most of her career in Europe, where she was famous for her revealing, self-sewn "Salome" costume.

She published a sex manual for women in 1900, had a lesbian secretary and lover, and in 1918 would sue British MP Noel Pemberton Billing for alleged libel when he wrote an article about her called *The Cult of the Clitoris*. Among other things, Billings accused Allen of having German lesbian associates during the World War and, *perhaps* worse, necrophilia.

Allen would lose her lawsuit, but that particular unhappy chapter of her life was still several years in the future when Ben Harris approached her in 1912. It appears that Harris did persuade the dancer

to come to New York. Fortunately for Allen, she chose not to accompany the man on his return passage to the U.S.

The ship that was to carry him back to New York was the *Titanic*.

According to Harris's wife, who was with him on the voyage but survived the sinking, her husband began to enter a lifeboat but then stepped back and refused to save himself, allowing other passengers to fill the boats instead.

"My God! Poor Henry!" she cried to friends who were attempting to console her, "He was a brave man!"

On April 21st, the *New York Times* posted the following memorial:

> The Association of Theater Managers of New York yesterday adopted a resolution of regret at the death of Henry B. Harris, Vice President of the organization, who was lost on the Titanic.

IN LATE OCTOBER, *VARIETY* NOTIFIED ITS READERS THAT MARIE Empress was returning to the stage.

> Marie Empress is about to reappear in a new and elaborate act, staged by Jack Mason. There will be three people and a piano in the turn. Miss Empress is said to have gone at the vaudeville subject more seriously than before, when she placed too much dependence upon the large quantity of publicity received by her.

But Empress did not appear. She abruptly cancelled her engagement, and, on November 30th, she sailed to Liverpool aboard the steamship *Baltic*. Ironically, it was the *Baltic* that had, just a few months previously, wired the following message to the RMS Titanic, just before it sank, with Ben Harris aboard:

> Greek steamer Athenia reports passing icebergs and large quantities of field ice today...Wish you and Titanic all success.

It was also the *Baltic* that would be chosen, years later, to carry

Major General John J. Pershing and his staff to England when the United States entered into the Great War.

Empress's name is listed at the top of the First Class manifest, which is somewhat significant, in that the names immediately below are those of Lord and Lady Richard Cavendish, and daughter Elizabeth. Presumably, the names were taken as passengers embarked - they are not in alphabetical order - which raises the possibility that Empress was, if not traveling with the Cavendish family, at least freely associating with them. Empress's mysterious connections to British political figures, the aristocracy, and the Freemasons (to include Lord Cavendish) will be explored later.

Three weeks later, on December 21, 1912, Marie Empress sailed from Liverpool back to New York aboard the *S.S. Campania*, which offered some of the most luxurious First Class cabins ever built. Upon her arrival, Empress checked into the Waldorf-Astoria, which coincidentally had just completed another dog show, in which the performer's "Empress Mite" took 2nd place in the Toy Black and Tan Terrier competition.

4

THE LEGITIMATE THEATER (1913-1914)

> Oh, happy is the lady who has seventeen Aigrettes,
> And she's the most agreeable of girls
> Who owns a few chinchilla coats and many sable sets,
> And hasn't got the time to count her pearls,
> One can always wear the finest dress that's in the room,
> Then one can always wear the brightest smile,
> For certainly the mental state that's wholly free from gloom
> Is when you cost a lot and lead the style!
>
> — LYRICS FROM *THE LITTLE CAFE* (1913)

Empress's activities in early 1913 are mostly unknown. She spent some of that period in England, which we know only because a manifest exists that show she sailed from there to the United States on May 24 aboard the *S.S. Caronia*. That same manifest indicates she intended to check into the Hotel Van Cortlandt, 142 W. 49th St. Niagara, New York, upon her arrival.

Empress opted to take a break from vaudeville. This is not surprising, given the death of her agent, Ben Harris, the razing of Young's Pier Theater, her humiliation at the Victoria, and the financial collapse

of the Folies Bergere. American Vaudeville, had not been kind to Empress.

She began a new career as a player in New York musicals, where prospects were bright for a beautiful young woman who could act, sing, and dance. Empress's first appearance was in the musical *Peg O My Heart*, which premiered on September 10, 1913, at the Stratton Theater in Middletown, New York.

Marie Keos in "Peg O' My Heart" at the Stratton Theatre Wednesday Night.

Her role on the first outing was small, and we only know of it because her photo and name appear in a September edition of a local newspaper. Her name does not appear as a cast member in any surviving documents, despite the fact that there were over 600 performances of the play from 1912-1914. It is possible that she was a replacement (perhaps even an understudy) for Christine Norman, who played the role of "Ethel," and who was said to have retired from the play for a short period due to illness.

Interestingly, the caption beneath the photograph of Empress identified her as "Marie Keane."

Why was she not then using her stage name, Marie Empress? One

possibility is that she was auditioning under her "real" name to conceal the fact that she was the woman who had disappointed audiences at the Victoria in 1910. A more likely reason, suggested in a 1915 interview, is that she had tired of the stage name. She was putting vaudeville behind her and wished to rid herself of her vaudeville stage name.

The change proved temporary. Only two months later, she appeared in another play, *The Little Cafe*, again billed as Marie Empress. *The Little Cafe*, a musical comedy in three acts, premiered on November 10, 1913, at the New Amsterdam Theater in New York.

Imported from France, the play revolves around the adventures of a carefree waiter in a small cafe who unexpectedly becomes the heir to a great deal of money. Two schemers come up with a plan to deprive him of some of his fortune. They trick the naive waiter into signing a contract that grants them a third of his wealth unless he continues to work as a waiter for the next 20 years.

They obviously expect him to break the contract - why would a rich man continue to wait on tables? - at which point they will collect their sizable penalty. To their surprise, their target is more than happy to continue his life as a waiter. Little do they know that he spends each night living the good life, patronizing the Grand Gala restaurant, where he is liberal with his money and has friends galore. In 1931, Maurice Chevalier would play the lead role in a film adaptation.

Empress played the part of Loulou Millefleurs (French for "A thousand flowers"), a role that was at the bottom of the playbill, at #23. Still, she was not unnoticed. A reviewer for the *Hartford Courant* reported that Empress was "more attractive than ever," and, "in a part that gave her little opportunity, won on her winning personality."

The *Washington Post* noted her as a "prominent" cast member and said the play was received with "great enthusiasm." The *Times* did not offer a review when the play came to the New Amsterdam Theater, but its editors chose to use only one photograph when announcing the play's arrival in the area - one of Empress.

The *New York Sun* reported that Marie Empress was cast in a role that gave her "almost no opportunities" yet she "revealed a most agreeable personality and a talent for acting when she had practically nothing to act that made the audience wish for a great deal more of

SAMUEL FORT

Marie Empress
"The Little Cafe
New Amsterdam Theat.

her...her petite brunette beauty provided a striking contrast to Miss Dawn (another actress in the play)."

While *The Little Cafe* was a remarkably successful endeavor for Empress, she was the restless type. After a year of performing the role of LouLou Millefluers, the English-woman gave up theatre just as abruptly as she had given up vaudeville. She decided that she wanted to be part of the most novel of all venues.

Motion pictures.

5

THE VAMPIRE (1915)

Phyllis: You - you - love - some one - else?
Imp (in agony): I - I - couldn't help it really.
Phyllis: Tell me everything. I - I won't faint, I can be very brave.
Imp: I will - there isn't much to tell.
Phyllis: Who is she?
Imp: She's the most beautiful woman in the world.
Phyllis: Oh, Imp - what does beauty matter? Is she very - very good?
Imp: Er - of course, she's good.
Phyllis: Is she very - very religious - and domesticated?
Imp: I don't know about very religious or the other thing. But she's got glorious eyes. Oh, if you could only look into her eyes - you'd know how good she was then!

— SCENE FROM *WHEN WE WERE TWENTY ONE*
(1915)

Marie Empress had achieved a fair measure of success when she abandoned vaudeville for the stage. Still, she was far too talented, charismatic, and ambitious to spend the remainder of her career in the periphery of the limelight. Unlike

vaudeville, the stage required that she recite lines, sing songs, dance numbers, and don costumes provided by others. Having spent her early years scripting her own performances and monopolizing center stage, sharing the floor with so many other performers and being unable to contribute artistically to the musical productions in which she was cast must have been suffocating.

Fortunately for the stifled artist, by 1915, a new outlet for performers, the *motion picture*, also known as the *photoplay*, was usurping live theater as the preferred entertainment choice for escapists around the world. Empress was ambitious and beautiful, and she was getting good press, with photographs of her appearing in New York newspapers. She was also an experienced self-promoter with excellent connections in the entertainment world. It is likely that she approached, or was approached by, a motion picture The Shubert Film Corporation would produce Empress's first film, *Old Dutch*. Since Lee Shubert intended to film only those plays that he owned and had produced on stage, it is possible that Empress had played a role in one of Shubert's plays. Perhaps not coincidentally, Lee Shubert would also produce the 1914 movie *Consequences*, which was directed by Gaston Mervale, who also directed *The Stubbornness of Geraldine*, one of Empress's earliest films.

Old Dutch, directed by Frank Crane, was a 5-reel comedy released in February of 1915. The length of films of the early silent era was not measured in hours and minutes, but rather in the number of "reels" the movie consisted of a reel of film, which was a thousand feet long, ran for about 11-12 minutes, depending on how fast it was projected. A 5-reel film was essentially a one-hour movie.

According to *Moving Picture World,* the April 21, 1915, *Dutch* was "a large and expensive production." Though set in Palm Springs, Florida, the film was made in the New York area (possibly using World Film's Fort Lee, New Jersey's facilities).

According to *Arcade Weekly*, March 27:

> There is a scene in the film in which, at a large Florida hotel, it is necessary to have a group of beautiful girls. Frank Crane, the directory of the picture, determine to have the most beautiful models he could procure, and instead of going to the theater for them, went to the

studios of the best-known illustrators in New York - those having pleasing drawings and sketches of feminine types which delight us on, and in magazines, books, bill boards, etc.

Lee Shubert was willing to invest a sizable sum of money in the movie because it was an adaption of a successful and highly profitable play that had he and his brothers had shown in their Herald Square, New York theater starting in 1909. A significant factor in the play's success was the performance of actor-comedienne Lew Fields in the title role, and Shubert hired him to replay that role in the film adaptation.

In the film, an inventor nicknamed "Old Dutch" invents a device he calls a "teleptophone," a device that could be attached to a normal telephone to allow both parties in a call to see one another - in other words, an instrument that would turn a telephone into a videophone. Yes, Old Dutch was about a century ahead of his time!

The inventor is given a $5,000 check by investors as a first payment for the invention, so he takes his daughter to Palm Beach to celebrate. He decides to use a false name when signing the guest register because his actual name has been widely reported, and he is seeking refuge from the public and press.

Unfortunately, while butterfly hunting, Old Dutch loses his wallet. It is found by Harry and Mildred Bennett (George Hassell and Marie Empress), an unscrupulous couple who steal the identity of Old Dutch and his daughter. They use the inventor's reputation as collateral to run up some sizable debts. Meanwhile, Old Dutch and his daughter are called upon to work menial chores at the hotel to pay their bill. Ultimately, of course, Old Dutch is made whole, and we learn that crime doesn't pay.

Reviews of the movie were positive. One reviewer penned:

The reputation of such a star as Fields is enough in itself to make the success of any comedy but when it is coupled with such stars as Vivian Martin and George Bassell, who both star with Lew Fields in 'The High Cost of Loving'; Marie Empress, the famous English music hall star, Charles Judels of the "Twin Beds" Co. and Charles Prince who

was the principal comedian with May Irwin Powers and other noted players, it is safe to say that this comedy will meet with the greatest success...

An advertisement for the movie just to the right of that review failed to include Marie Empress's name - evidence that its creators did not think her name recognizable enough to draw patrons into the theater. In fact, most advertisements for *Old Dutch* either neglected to include Empress's name in the cast credits or listed it in small print, which is quite understandable, given this was the young woman's first film.

Still, Empress's appearance was singled out by at least a few reviewers. A writer for the February 26th edition of the *Syracuse Herald* advised readers that:

Marie Empress, the English concert hall artist who has only made brief visits to the United States, appears as the adventuress in 'Old Dutch'

...and a Pennsylvania reviewer enticed his readers to see the movie with the observation that Marie Empress was "a famous English music hall star and a noted beauty."

A March 13th review in the *Racine Journal* was more generous with its ink:

Marie Empress, the English comedienne, is the scheming vaudeville girl in 'Old Dutch,' who impersonates 'Old Dutch's' daughter, thus constituting herself the villainess of the drama, and causing most of the trouble around which the action revolves at Palm Beach, where 'Old Dutch' and his daughter go to stay. The photoplay opens in New York and some of the characters are introduced on the escalator at Macy's, Marie Empress herself emerging from the variegated and moving throng, typical of the fascinating and picturesque mosaic of femininity always to be seen in Macy's great carnival of fashion.

Old Dutch did sufficiently well at the box office that Frank Crane

was tasked with filming another Lew Fields feature a few months later titled *All Aboard*. Empress did not have a role in that film.

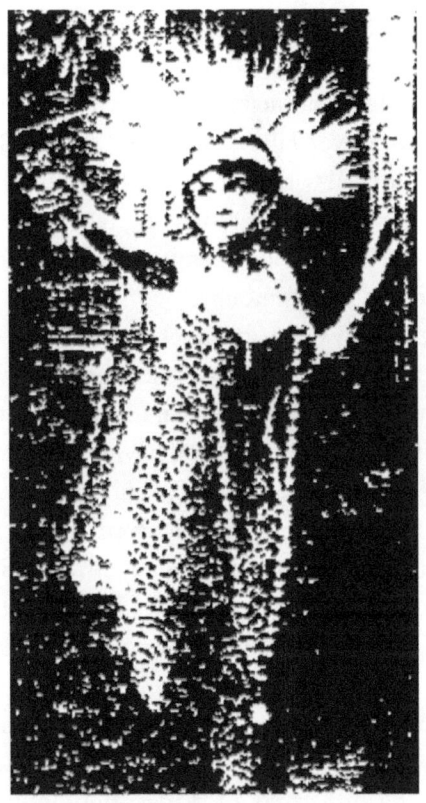

Empress's second movie release in 1915, *When We Were Twenty One*, based on a play by H.V. Esmond, was produced by Famous Players films and distributed by Paramount. Famous Players was on the verge of merging with the Jesse. L. Lasky Feature Play Company. Jesse L. Lasky was, of course, the former partner of Empress's former manager, Ben Harris, in the failed Folies Bergere venture. Not surprisingly, Lasky had grown disenchanted with the tribulations of live theater and had moved back to his home state of California to try his hand at motion pictures.

As fate would have it, his sister, Blanche, married Samuel Goldfish (later, more famously, Goldwyn), and in 1913 Lasky teamed up with

Goldwyn, Cecil B. DeMille, and Oscar Apfel to create the Jesse L. Lasky Feature Play Company, which produced Hollywood's first feature-length film, *The Squaw Man*, in Los Angeles. Lasky gave the job of General Press Representative to Harry Reichenbach, whom Empress would have known well, since the promoter had spent much of his career in charge of publicity for Henry B. Harris.

In 1914, Famous Player Films and Jesse L. Lasky Feature Plays had signed a distribution deal with Paramount Pictures. Amazingly, by 1915, Lasky had taken control of Paramount by buying up a majority of its stock, forming the Paramount-Famous-Lasky Corporation, which today is simply known as Paramount.

When We Were Twenty One was directed by Hugh Ford and Edwin S. Porter. Ford was a well-known theatrical producer who had moved to Los Angeles to work for Famous Players in January of 1914. Edwin S. Porter was one of the pioneers of film, having directed *The Great Train Robbery* in 1903. Just a few months before filming *Twenty One*, Ford and Porter had directed a young Mary Pickford in the 1914 film *Such A Little Queen*. Ford had written that film with the help of Channing Pollock, one of the co-writers of the Folies Bergere 'Hell' production.

In *When We Were Twenty One*, Empress was cast as Kara Glynesk, also referred to as "The Firefly," an unethical yet beautiful burlesque dancer at The Corinthian Club. The Firefly uses her skills of seduction to take advantage of an innocent young man (the "Imp") whom she mistakenly thinks has inherited a fortune. Her victim marries her, but when she learns he is poor, she tosses him aside. As typically happened in movies of this era, the young man lands on his feet, wiser and no worse for wear.

The Firefly was a career-making role for Empress. Adorned in a form-fitting, low cut, leopard-spotted dress, the slender young woman radiated sensuality. Her delicate fingers were adorned with stone-encrusted gold rings, and a long string of pearls was woven around her neck and arms like a serpent. A jeweled band supporting an impressive plume of feathers was wrapped around her head. She was the epitome of what would soon be called a "vampire" or "vamp" - a woman who used her sexuality to get what she wanted, whether that was a man's money or a woman's husband.

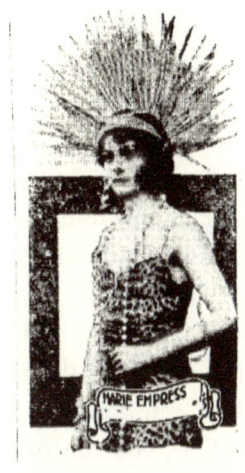

Empress was so successful at capturing the Firefly's sensuality and selfish, malevolent nature that film critics heralded her as one of motion pictures' "great vampires." A reviewer for the *New York Times* took particular notice of Empress's stripping skills, stating that she put "a new feather in the act of disrobing."

In Kansas, Empress's performance almost led to riots. Censors in Topeka tried to prevent *Twenty One* from being shown, which did not sit well with potential viewers. In one Topeka theater, the management handed out printed cards to viewers who had just left a screening of the film. The cards posed a single question: "Should this picture be condemned or not?"

Twenty-eight viewers said that it should, but the great majority, five hundred and four, said it should not be.

The *Topeka Journal* attempted to defend the movie, stating that Empress's dance was "graceful and not obscene." Nevertheless, the movie was banned in Kansas that April, causing what newspapers reported as a "near riot" among hopeful viewers.

Though Empress played several benign characters in subsequent years, advertisers continued to announce her as "Marie Empress, the sublime vampire!" or "Marie Empress, the great vampire!" when they ran advertisements for her movies.

Most often, promotions dubbed Empress as "The Sublime Vampire Woman." Audiences loved movies that included sexy, diabolical female characters, and reminding viewers that Empress was a vampire was an excellent way to sell tickets, whether or not she played a vamp in the particular movie being promoted.

While *Old Dutch* and *When We Were Twenty One* were showing in theaters around the nation, Empress was already in Jacksonville, Florida, filming a third movie, *The Stubbornness of Geraldine*, based on a play by Clyde Fitch. The Art Film Company produced the movie, and the cast included Laura Nelson Hall, Mary Moore, Daisy Belmore, Vernon Steele, Stanley Harrison, and Paul Ferrer.

In *Geraldine*, a young American woman of means (Geraldine Lang) has been living in Europe for several years and is about to return home. Before her voyage, she attends a masked ball where a debonair Hungarian Count meets and becomes infatuated with her.

As fate would have it, he is sailing to America on the same ship as the heroin, and the two meet again and fall in love. Their new romance is put on hold when another passenger, a woman, accuses the Count of seducing, abandoning and causing the suicide of a girl in England.

Despite the evidence against him, young Geraldine stubbornly refuses to believe the Count is guilty of the accusations. Happily, by the last reel, the hero has cleared his name (the interloper had mistaken the Count for his older, less ethical brother), and the two young lovebirds marry and return to Hungary to live happily ever after.

Mysteriously, *Geraldine* received so little coverage upon its release that many modern sources speculate that the movie was never completed. But it was both completed and released, as evidenced by an announcement in the *New York Times* on August 22, 1915, that the film would be shown for two days at Brighton Baths.

That there are no reviews, good or bad, suggests *Geraldine* did so poorly at the box office that most theater owners stopped showing the film before a critic had an opportunity to view it. The movie's director was the Australian-born actor Gaston Mervale, who had directed nine other films in the previous four years, but who would never direct again after *Geraldine*. Geraldine was also the last film ever produced by the Art Film Company.

Geraldine's failure had no impact on Empress's rising fame. On July 17, 1915, she attended the Fifth Annual Meeting of Motion Picture Exhibitor's League in San Francisco. A migration of the movie industry from the East Coast to Los Angeles had begun in 1910, and by 1915, more motion pictures were being made on the West Coast than the East.

All the major players attended the glitzy event, to include directors such as Cecil B. DeMille and D.W. Griffith, actors and actresses such as Lillian and Dorothy Gish, Geraldine Farrar, Blanche Sweet, Mack Sennett, Frank Keenan, and William Duncan, and other notables, such as the famous aviator Art Smith. Also present were a slew of politi-

cians, led across the Rockies by Massachusetts Governor David Walsh, proof that some things never change.

When the convention was over, Empress returned to the East Coast and began filming her next movie, *The Woman Pays*. It was a Columbia Picture, and at that time, Columbia was a New York production company. The 5-reeler was directed by Edgar Jones and starred John Bowers, the German actress Valli Valli (yes, that's "Valli" twice), and Edward Brennan.

In the film, Empress was cast as Connie Beverly, a widower who falls in love with a married man, Phillip (Edward Brennan) and seeks to destroy his marriage so she can have him for herself - a classic vampire role. The widow is assisted in her scheme by John Langton (John Bowers), a former suitor of the man's wife, who is equally anxious to end the marriage.

The two schemers trick the vain wife, Beth (Valli Valli), into leaving her husband by convincing her that her indebted husband cannot provide her with a good and respectable life. Still, as one would expect, by film's end, the couple are together again, wiser and more in love than ever, though in a peculiar plot twist, the wife has been humbled due to a scar on her face from a lightning strike!

According to an article published on October 26th in the *Logansport Pharos-Reporter*, Valli-Valli was temporarily blinded when a bucket of water was poured over her in preparation for a scene in which she needed to appear rain-soaked. The bucket contained fine particles of grease that got into her eyes. Another trivial tidbit about the movie comes, from of all places, Volume 29 of *Mekeel's weekly stamp news*, which reported that movie censors had required the removal of two scenes because they showed...*stamped envelopes*.

Filming of *Woman* was complete by mid-October, allowing Empress to again indulge herself in her favorite hobby - dog shows. On October 15th, the *New York Time*s reported that "Empress Baby," the actress's newest diminutive charge, was the tiniest entry in the Toy Dog Club's

show at the Hotel McAlpin, with a length of just five inches. The pooch might have been small, but it was also a quality performer, winning a blue ribbon in the toy black and tan category.

The Hotel McAlpin, in Manhattan, was at that time the tallest and one of the most luxurious hotels in the world. Coincidentally, it was at the McAlpin that several independent film distributors, exhibitors, and producers met in October of 1914 to form an alliance aimed at breaking the Edison "trust" that was attempting to monopolize the movie industry. Among the many participants was H.M. Horkheimer, one of the future owners of the Balboa Amusement Producing Company, a giant in the movie industry, and producer of several films in which Empress would eventually star.

THE MYSTERIOUS MISS EMPRESS

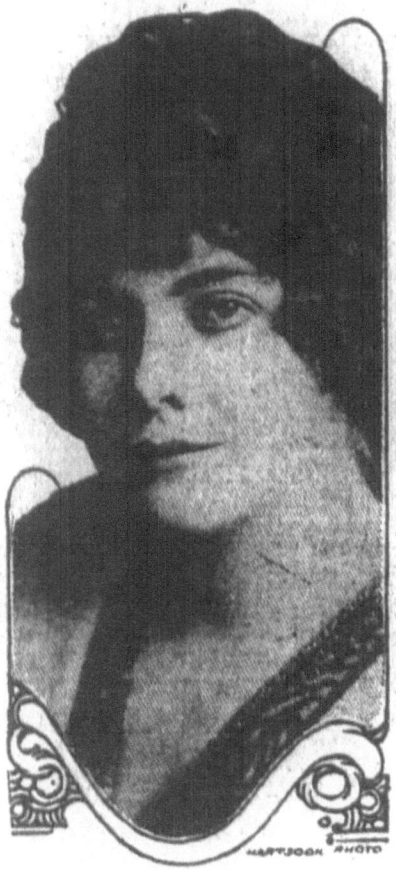

Marie Empress, dramatic star, who makes her initial appearance on the photoplay screen in "When We Were Twenty-one."

Marie Empress's photograph in a nationwide advertisement for When Were Twenty One

6

MISTRESS OF DISGUISES (1915)

"You're a strange creature."
"Not at all. It's you people here who are strange - I'm just what I am. I don't pretend or want to be anythin' else. But you - all of you - seem to be trying to be somethin' different to what ye are."
"What do you mean?" asked Ethel suspiciously.
"Oh, I watch ye and listen to ye," went on Peg eagerly. "Ye turn yer face to the wurrld as much as to say, 'Look at me! aren't I the beautiful, quiet, well-bred, aisy-goin', sweet tempered young lady?' An' yer nothin' o' the kind, are ye?"
Ethel went slowly over to Peg and looked into her eyes.
"What am I?"

— SCENE FROM *PEG 'O MY HEART* (1913)

The *Woman Pays* was released in November 1915 and received mixed reviews by critics. *Variety's* reviewer was underwhelmed by the performances of both leads, commenting that Valli Valli "seemed camera-struck and when she didn't it was about the same" and that Edward Brennan was artificially rigid,

seeming to "set" himself at the start of every scene he appeared in. Ultimately, the reviewer decided that the film "won't break or make Columbia (Pictures)." One wonders if Valli's poor performance might be at least partially explained by the temporary blindness she suffered during filming!

Empress's performance was not subject to *Variety's* derision, and it appears her performance was one of the few positive aspects of the motion picture. Despite being only a supporting player, she became the face of the film in newspapers around the U.S. One reviewer took particular notice of both her beauty and her passion for jewelry.

"In 'The Woman Pays," he wrote:

> Miss Empress wore jewelry valued at almost half the cost of the big production. Among the pieces of jewelry was the famous pair of Dujordt earrings that Miss Empress secured at Monte Carlo, when she was being featured at the Folies Bergere in Paris. She collected many of her rarest gems during the two years she was starred in big productions in South Africa.

A critic for the *Newark Daily Advocate* remarked that Empress was "dashing" in her portrayal of the vampire-widow, adding that she "is one of the few internationally famous actresses. She is well known on the American, London, and Paris stages. In addition, she is one of the best known male impersonators; many persons rank her ahead of Besta Tilley, the famous English music hall artists."

Indeed, Empress's reputation as a master of disguises and character impersonator was very highly acclaimed on both sides of the Atlantic. Prior to coming to America, Empress had developed numerous stage characters for her standup routines and, by all accounts, she had the uncanny ability to "become" her characters. She was well known for her skill at impersonating males, especially boys.

As reported in a 1915 issue of the *Ft. Wayne Journal Gazette*, "While Miss Empress is perhaps best known in this country for her marvelous portrayal of vampire-types, she is equally as good in boy parts, and appears to take advantage as a male in evening clothes."

One of her recurring male characters from her time in vaudeville, and the only one for which there remains photographic evidence was "Chappie," an English gentleman decked out in tux, top hat, and cane.

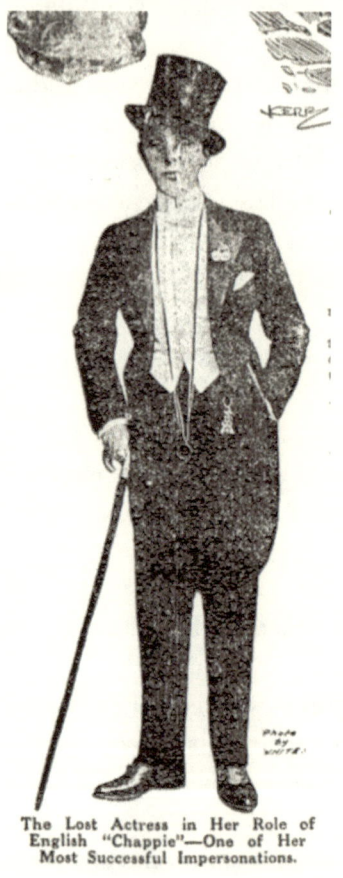

The Lost Actress in Her Role of English "Chappie"—One of Her Most Successful Impersonations.

It was no surprise when a syndicated gossip column called *Fodder for Foto-Fans*, dated November 13, 1915, reported, "Marie Empress, the versatile continental actress, who is featured with Edward Brennan in 'The Woman Pays,' a new Rolfe-Metro photodrama starring Valli Valli, has written the scenario for a feature picture in which she hopes to be starred. Miss Empress has written a role for herself that calls for the delineation of six distinct characters. In, each part she has been starred in previous stage productions on the other side of the Atlantic."

Empress proved to be both a quick writer and promoter - only two months after that interview, her dream was reality. The movie that resulted was released in January of 1916 bearing the title *Behind Closed Doors*, though Equitable Films re-released it as *Loves Crossroads* on April 21 because, according to the distributor's representative, another movie had been released at the same time bearing "a somewhat similar name." It was also re-released as *Love's Crossed Trail* in a handful of markets. Yet another release of the movie in December 1919 bore the title of *The Guilty Woman*.

The movie was a 5-reeler, and, just as she had planned, Empress utilized the film to display her impersonation and disguise skills, playing five different characters, male and female, from a vamp to

street kid, in addition to the movie's lead, "Inez Valenti." Her most important role was as the author, or at least co-author, of the screenplay, an accomplishment for which she has never received credit. Most modern sources list Eve Unsell as the sole screenwriter.

The movie has been lost, and no script is known to exist, but newspaper reviews of the period tell us much about the plot and Empress's performance. According to the June 28, 1916 edition of the *Portsmouth Daily Times*, the movie was:

> ...a five part mystery melodrama, directed by Joseph A. Golden and featuring Marie Empress in the role of partner of the proprietor of a gambling house. The mystery centers on a murder and is not explained until the last reel. Marie Empress, the feature player, is permitted to appear in various disguises. The fact that Inez, usually immune to kindly feelings, happens to fall sincerely in love with one of her victims accounts for much that happens the fatal night in the gambling house.

A reviewer for the Racine Journal-News advised its readers that:

> Marie Empress, a stage and screen star of pronounced excellence, whose marked personality and unequivocal success as an actress in emotional and sensational roles have won her prominence in her particular field, will be seen at the Rex tomorrow. Her part as the more sinned against than sinning victim (and who) makes the supreme sacrifice when she finds herself unable to cope with the results of her life of mystery, reveals unexemplified capabilities and shows the actress of consummate skill, vivid intelligence and tremendous strength. The scenes of this photo-play are laid in New York (and the) wonderful underground of the great city, gambling houses and slums, and some remarkable pictures showing how a siren lures men to their financial destruction.

The *Atlanta Constitution* added:

> The vivid and thrilling story is that of a girl sold by gypsies to a

gambler. Wonderful views of the night side of New York city are shown, revealing gambling houses, slums and other places.

As reported in the *Salt Lake Tribune*:

The underside of New York life, with love, jealousy and sacrifice as the motifs of the plot is set forth in remarkable manner...The star of the play, Marie Empress, has won an enviable fame for her impersonation of difficult vampirish roles, and in this production a unique and interesting story has given her dramatic powers full scope. The fate of a woman who, while acting as a lure for her uncle's gambling house, falls in love with a straight-forward, honest man, who in turn is in love with a woman of his own class in life, furnishes a theme which provides almost unlimited opportunities for fine dramatic action, tense situations, and thrilling climaxes.

Most revealing is this synopsis from the *Portsmouth Daily Times*, March 22, 1916, which we are fortunate to have, now that the film is lost, but which must have been a real spoiler for readers of the time who had not yet seen the film:

The story - That of a girl sold by gypsies to a gambler, trained to be a lure for other men and a victim of the gambler's passion, meets and loves a man of good standing, causing a fight through jealousy, in which she shoots the gambler, only to find that the other man is faithful to his childhood's love. She permits him to be arrested and tried for the murder, but reveals the secret of the house of mystery in a written confession which tells her story and clears the man, and then commits suicide, paying the wages of sin and leaving the lovers saddened but happy.

The movie was still being shown as late as 1920. On May 11 of that year, a *Hartford Courant* reviewer marveled at Empress's sense of fashion, as well as her acting ability. In an article titled *Marie Empress Wears Many Stunning Gowns in Leading Role,* the reviewer suggested an alterna-

tive explanation for Marie Keane's use of the pseudonym of Marie Empress:

> Admirers of motion picture stars have often wondered how their favorites selected the pseudonyms they use for screen purposes. Marie Empress...is considered by many fashion experts to be the empress of fashion in the film world...In the Guilty Woman, she is accorded ample opportunities to wear many stunning sartorial creations that presumably bear the trademarks of Parisian modistes.

The reviewer then makes a comment that will be reiterated by others in the future, which is that Empress had redefined what it meant to be a "vamp" in film.

> Her role is not unlike the one made famous by Theda Bara; but her acting is far more effective and convincing; and her eyes flash and seem to carry a message even though her lips are tightly pursed.

Empress continued to compete in dog shows while filming, as captured in this December 4, 1915 article from *The Moving Picture World*:

> Up in the Bronx Marie Empress and her prize winning Manchester black and tan "Baby," are busy with the first scenes of "Behind Closed Doors," under the direction of Joseph A. Golden, of Triumph, the Equitable's producing ally. The actress, of course, is the star of the play, but the dog, which is regarded as the most valuable 30 ounces of canine flesh in New York, will have an appearance, if not a speaking part, in the new production.

In fact, as *Behind Closed Doors* was being filmed, Empress's love of small dogs became a source of amusement for reporters. The December 16, 1915 issue of the *Chicago Daily Tribune* reported:

> Emmy Wehlen (an actress) and Marie Empress of the Metro studio in New York are passing without speaking these days. The bone of

contention – or bones – being two small dogs. Miss Wehlen owns a Pekinese weighing not more than two pounds; Miss Empress owns a Biscuit Hound not larger than a male's hand.

Whether the reported rivalry was real or fabricated to amuse readers is best left to the imagination.

7
THE GRIP OF EVIL (1916)

Dick (slowly): What does your judgment prompt you to do?
Imp: To marry the woman I love
S. Man: The Firefly.
Dick: She - she is a good deal older than you are - isn't she, old man?
Imp: She is a little older.
Dick (slowly): And I hear - that she has traveled a great deal.
Sir H. (chiming in): I suppose you know what people say -
Imp (interrupting): I should have thought, Sir Horace, you'd have learnt by this time to pay no attention to "what people say."

— SCENE FROM *WHEN WE WERE TWENTY ONE*
(1915)

By 1916, Empress's fame was sufficient that Mabel Rowland, who was writing a book with the title *Celebrated Actor Folks Cookeries*, asked the star to contribute a recipe for inclusion. The book was written to earn money for the Red Cross (recall that World War I was being fought at this time) and the Actor's Fund, and included recipes by dozens of notables in addition to Empress, to include Roscoe Arbuckle (Fricassee of Lobster and Mushrooms),

Theda Bara (Snails A La Mouquin), Charlie Chaplin (Apple Roll), Douglas Fairbanks (Southern Style Chicken), Mary Pickford (Raspberry Jam Tarts), and many others. Empress's contribution was "Green Tomato Pickle," which requires that a gallon of unpeeled green tomatoes and six large onions be mixed with vinegar, brown sugar, salt, pepper, mustard seed, allspice, and cloves, then stewed and canned.

As might be expected, given Empress's increasing celebrity, interviewers began to question the actress about her love life. She was, after all, a "vampire," a beauty that would have been the dream of many men, but she was not known to have any romantic entanglements. This suggested to some followers that she might be secretly married, a suggestion Empress quickly dismissed. Her only marriage was to her career, she claimed.

"Hercules takes all my spare moments," she told a reporter in the May 21st, 1916 edition of the *Salt Lake Tribune*. Hercules was her newest dog. One assumes the name was a misnomer.

Following the completion of her commitment to Columbia, Empress again disappeared from public view for several months, and her fans began to speculate that she might have abandoned films to resume an international vaudeville career. A report in *Variety* that February of 1916 seemed to confirm the rumor: "Mare Empress sailed last week for South Africa to remain there for six months playing in vaudeville."

However, in March of 1916, a reporter said he had spotted Empress driving along a beach in California, while another advised that Empress was "in Los Angeles, 'vampiring' under the tropical sun." At length, Empress decided to end her seclusion and granted a writer for the *Film World News* a brief interview.

"Marie Empress," the *News* correspondent wrote, "wishes to deny the reports that she has left the United States of America for South Africa, Australia, or any foreign place. When she said good-bye to 'Noo Ya'k' recently it was for Long Beach, Cal., where she is filling an engagement at the Balboa studio. Miss Empress is doing the 'heavy' in a continued screen story featuring Jackie Saunders, which will be released by Pathe."

Jackie Saunders was a Balboa studio celebrity who was known as

"the Maid of Long Beach" and the "Mary Pickford of the West Coast." In 1916, she would marry Elwood D. Horkheimer, one of the two brothers who founded Balboa Amusements. A prolific performer, her 1916 films included *The Heartbreakers, The Flirting Bride, The Child of the West, The Shrine of Happiness, The Girl Who Won,* and *The Twin Triangles.*

The "continued screen story" referenced in the article was *The Grip Of Evil,* and it was not a movie per se, but rather a 14-week serial. A serial of the era was a theater mini-series, with new two-reel episodes being released every few weeks to theaters.

Serials were highly profitable. The short episodes could be pumped out faster and cheaper than a stand-alone movie, and viewers of the previous episodes were likely to return to theaters to see future ones. Serials were also popular with theater owners who wanted short one and two-reel films to show in the summer months. Twenty minutes was as long as many viewers would tolerate a hot, non-air-conditioned theater.

Grip was different from most serials of the time in that there was no continuous narrative; each episode was a stand-alone tale. Saunders played a different character in each film. What made *Grip* a series was that all 14 releases shared the same theme, which was the extent of evil in the modern world.

Producing the films on-schedule was a challenge, and Balboa had cast almost its entire stable of stars in the serial by the time the last chapter was filmed. The *New London Connecticut Day* reported that, "the 12 stars in the Pathe serials now being shown include Pearl White, Ruth Roland, Grace Darmond, Jackie Saunders, Frank Mayo, Sheldon Lewis, Roland Bottomly, Ralph Kellard, Anna Nilson, Creighton Hale, Tom Moore and Marie Empress." Pathe was the distributor of the film.

According to a July 1916 article in the *Atlanta Constitution,* Empress "was selected by the Balboa company to portray the 'vampire' roles in 'The Grip of Evil,' the story of humanity being released through the Pathe exchange."

The article's author observed that the English actress was

redefining the role of the vampire in motion pictures. Marie Empress was "a vampire more 'vampirish' than the one made famous by the 'rag and bone and hank of hair' description of Kipling's...She has become known in the film world as the true 'vampire' type."

The writer also marveled that Empress, unlike some of her peers, loved playing the detested character.

> (She) glories in all the execrations she wins from motion picture machines.
>
> The experience of the film 'vampire' has been a varied one...She has had important roles in comedy, drama, and opera. She was a London favorite and a member of some of the most famous British theatrical organizations. She won laurels on the dramatic stage in America before entering the motion picture field.

The 14 episodes of Grip of Evil were:
 1. Fate

2. The Underworld
3. The Upper Ten
4. The Looters
5. The Way of a Woman
6. The Hypocrites
7. The Butterflies
8. In Bohemia
9. The Dollar Kings
10. Down to the Sea
11. Mammon and Maloch
12. Into the Pit
13. Circumstantial Evidence
14. Humanity Triumphant

Like most films of the era, and all of Empress's, *Grip of Evil* is presumed lost. Fortunately, Balboa hired an author by the name of Louis Tracy to write not only the script but also a novelization of the movie. Though the novelization was never published in book form, a novelized version of each movie episode was printed in newspapers around the country whenever the film-version was appearing in local theaters.

This means that though the *Grip of Evil*, the film, is lost, the story and stills from the film can still be found.

Episode 5, *The Way of a Woman*, is the tale of Helen (Saunders), a good-hearted but desperately poor store clerk who lives in the slums with her mentally abusive and dysfunctional family. One day, a former co-worker, Alice Martin (Empress), walks into Helen's store, "attired in the height of fashion." Alice was once as poor as Helen, but tells her old friend, without embarrassment, that she has struck gold by becoming the mistress of aging, wealthy men. Later, Helen meets and falls for the series' protagonist, a handsome, wealthy, and morally upright John Burton.

Inspired by her gold-digging friend, Alice, Helen decides that she has but two paths in front of her - she must either convince the hero to let her live with him in sin, or else she must give herself to the highest paying stranger. When Burton refuses her advances, she tries

to force his hand by jumping onto a stage in a club full of rich, lustful men and announcing that she will give herself to the highest bidder, knowing that Burton could outbid any man present. Tragically for Helen, the hero's morality prohibits him from bidding. He does not love her, and cannot keep her as a mistress.

As related at the story's end:

"If You Play a Strong Hand, You've Struck It Rich."

Helen's eyes darted one last hungry glance at the man with whom she

would cheerfully have faced poverty and all that it meant. He interpreted aright that terrible look, and mournfully shook his head. She asked for love, and that he did not feel he could give, since his sad experience of life had seemingly made him bankrupt in life's most precious gift.

Knowing she had failed, Helen spurned him with a magnificent gesture. She whirled around upon the man who had named the highest price.

"You win!" she screamed, and flung herself into his arms.

That last dreadful cry rang in John's ears for many a day.

In the film still that accompanied the newspaper novelization of Episode 5, Marie Empress is seated next to a distraught Saunders, leaning slightly forward and toward the heroin, as if to advise her.

The caption beneath reads, "If You Play a Strong Hand, You've Struck It Rich."

8

A PRO-BONO PERFORMANCE

You know a conjurer gets no credit when once he has explained his trick; and if I show you too much of my method of working, you will come to the conclusion that I am a very ordinary individual after all.

— *A STUDY IN SCARLET,* SIR ARTHUR CONAN DOYLE

Though Marie Empress was already making movies in California by the summer of 1916, none of them had yet been released to theaters on the West Coast, and she was not well known in Los Angeles. She had spent most of her American career in New York, so that was where most of her films, vaudeville performances, and musicals had been promoted.

This provided Empress a golden opportunity to do what she did best – disguise and mischief.

The July 15, 1916, *Los Angeles Times* posted a large engraving of Empress dressed in high fashion, as always, with a large, stylish hat on her head, twirling a pearl necklace with one hand while holding a small dog against her bosom with the other.

THE MYSTERIOUS MISS EMPRESS

The headline was: *Marooned in America by the U-Boats*. The caption below her image read:

> Miss Marie E. Keen, daughter of the late John Keen, once Lord Mayor of London, would go home, but her relatives won't let her, for they fear the undersea peril. Miss Kean arrived in Los Angeles yesterday with a maid and her $4,000 prize toy terrier, Peanuts.

Note that the writer spelled the family name as both Keen and Kean in the same paragraph. The name would also appear as Keane and Keene in other sources.

In her new self-cast role, Empress was not a professional actress and not in California to make movies. Instead, she was a beautiful young woman from a prominent family – the daughter of a former Lord Mayor, no less – who was touring the world and found herself *stranded* in Los Angeles at the Rosslyn Hotel.

"If only the English or Americans would start a submarine passenger line across the ocean," she lamented, "I could return without disobeying my family, for they only forbade me to travel 'on' the ocean'"

It was a purposefully ridiculous comment, of course, but Empress the vaudevillian delivered it straight. She continued, "As it is, however, I supposed I must spend another homesick year in the United States, for my relatives say the war will last that long."

"We were in Holland when the war broke out," she told the reporter, "and my family promptly shipped me over here for fear the Germans would get me. Twice since then I have started to return, but each time they wrote me to stay; first because of the Zeppelin raids in London, and now because of the submarines."

It is true that she had not returned to England since the war began, and it is possible that she had been in Holland in 1914, as there is no record of her performing that year in the United States that year. However, there is also no record of her traveling under any of her many suspected pseudonyms, which means merely that if she did travel, she used still another.

Or perhaps this was yet another of Empress's clever twists of real-

ity. In 1913, and possibly 1914, she was appearing on stage in *The Little Café*. The initial venue? The New *Amsterdam* Theater – in Middletown, New York.

The *Times* writer advised his readers that the stranded woman had traveled all over America, Europe, Asia, and Africa, accompanied by only her maid and toy terrier, Peanuts.

Peanuts, the reported said, had won first prize at a winter dog show in New York. Kean's father was deceased, but the stranded woman carried with her his picture, which was that of a man wearing a huge jeweled necklace and breast chain. Empress, as Kean, told the reporters that the picture had been found among the belongings of her brother, who had been an officer in the Seventeenth British Lancers and had been killed at "Salonki," which presumably referred to Salonika, today called Thessalonika.

"Miss Kean," wrote the reporter, "is an accomplished linguist and is something of a painter. She was prominent socially in London and Paris and when a small girl was received by the late King Edward on one of her father's official visits to the palace. Except for her toy terrier...her most treasured possession is a priceless pair of earrings, which were heirlooms in the noted Dujordt family of Paris."

When the reporter asked the prim Miss Kean how she had obtained the earrings from the Dujordts, Empress said that she had been on a sightseeing trip in Monte Carlo, in 1912, and there encountered a wealthy young Parisian gentleman at one of the casinos. The man, a member of the Dujordt family, was enamored by the young Englishwoman, but she was more enamored by the earrings worn by the young woman who was with him. Empress - or Kean – told reporters that she had suggested a game of chance, wagering her prized terrier against the earrings.

She won. Pressed as to why her opponent would wager family heirlooms of such beauty against a dog, regardless of its pedigree, Empress coyly confessed that "there was a romance connected with the wager, and that Peanuts was not *all* that she staked."

THE MYSTERIOUS MISS EMPRESS

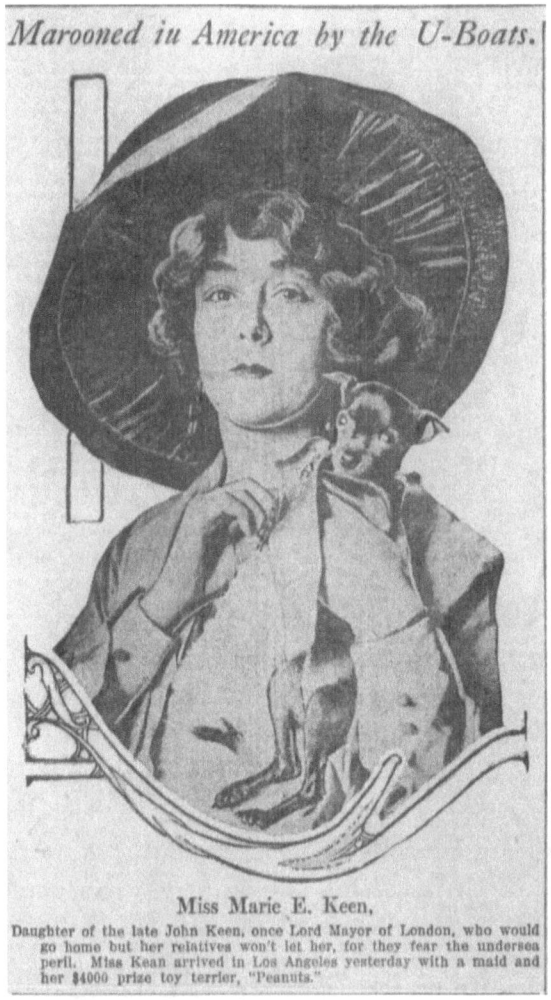

Marie Empress posing for Los Angeles reporters with "Peanut"

9

A PROLIFIC YEAR

Life is infinitely stranger than anything which the mind of man could invent. We would not dare to conceive the things which are really merely commonplaces of existence. If we could fly out of that window hand in hand, hover over this great city, gently remove the roofs and peep in at the queer things which are going on, the strange coincidences, the planning, the cross-purposes, the wonderful chain of events, working through generations and leading to the most outer results, it would make all fiction with its conventionalities and foreseen conclusions most stale and unprofitable.

— *A CASE OF IDENTITY*, SIR ARTHUR CONAN DOYLE

In addition to *Grip of Evil* and her self-produced "Miss Kean, stranded tourist" scenario, Empress completed at least six additional projects in 1916: *Sybil's Scenario, A Lesson From Life, The Chorus Girl and the Kid, Woman Redeemed, In the Hands of the Law,* and *The Girl Who Doesn't Know.*

Sybil's Scenario, a 3-reel Knickerbocker film, is perhaps the most obscure. It was released on July 21st, though apparently its run was

very short. Empress was cast in the lead role of "Mercedes Gonzales," a Spanish cabaret dancer. Mercedes has a daughter, Bernice (Lucille Pietz) whom she has essentially abandoned to the care of an elderly nurse, Mary (Molly McConnell).

When a wealthy club owner, James Harper (Philo McCullough) kidnaps Bernice, the nurse calls Mercedes to report the abduction. Fortunately for Bernice, Harper's kidnapping assistant, Hale (Bert Ensminger), has a change of heart and releases the girl, but not before she overhears enough of her kidnappers' conversations to know the location of their hideout. She provides that information to her mother, who, disguised as a boy (an Empress specialty), breaks into the kidnappers' apartment.

She is captured by an Oriental servant named Carib (Makato Inokuchi), but almost immediately the servant admits he pretty much hates his employer, and the two plan a kidnapping of Harper. Things do not go exactly as planned, as Harper is drowned instead of abducted, but mother and daughter are united for an otherwise happy ending.

Interestingly, the title of the film has nothing to do with the plot. Instead, it refers to the film's writer, Miss Sibyl Smith, whom Knickerbocker proudly proclaimed to be an amateur writer. Exactly why the studio elected to produce a film written by a completely unknown and untested writer is unclear. It may have been a publicity gimmick, as *The Moving Picture World* (V.29) wrote, "As many persons in the average audience are amateur scenario writers, (the film) should arouse intense interest...especially because it presents on the screen, for the first time on record, an amateur's script with all its faults and merits intact."

The actual identity of Miss Smith may be discovered in a later chapter.

A LESSON FROM LIFE IS NOTABLE BECAUSE FRANK MAYO HAD A supporting role, making *Lessons* one of his earliest projects. Advertisements and one review of the movie describe the movie's premise, telling us that it is both "the story of a charming novelist" and "the

story of a rising novelist who desires material for her new novel - how she secures it makes a thrilling story."

A synopsis in the *Hamilton Evening Review* of October 26 fleshes things out still further:

> *A Lesson From Life* at the Eagle on Tuesday night is that of a young woman, a playwright, who desires to get a touch of slum life in order to perfect her story. She resides in the slums and while there saves a burglar from the police. He falls in love with her. She is unable to shake him off. Many complications arise before she is rescued by her husband.

The *Moving Picture World* reported:

> There is an entertaining strain of humor running through the three reels of this film. It is more comedy-drama than straight drama. Marie Empress and Frank Mayo are featured in the story, which deals with the manner in which a novelist's wife, who aspires to be a playwright, is cured of her desire to get in close touch with her characters. The cure comes about when the wife goes to live in the slums, and Is amusingly "framed up" by the husband's actor-friend.

Nevertheless, the movie enjoyed the peculiar distinction of being banned in Quebec. The Bureau of Censor didn't think the film was funny at all, charging that *A Lesson From Life* was "immoral" because "Although but a dream, (the film) features exaggerated criminal scenes."

Empress's subsequent movie, *The Chorus Girl and the Kid*, should be remembered as the movie that introduced child-star Virginia Lee Corbin to her adoring public. As announced in newspapers:

> Friends of baby Virginia Corbin, three years old, will be pleased to know that she made her debut in motion pictures last week, featured with Miss Marie Empress, London star, in an emotional play [Chorus]. Those associated with the Balboa Company as well as her friends were much surprised by her clever work.

THE MYSTERIOUS MISS EMPRESS

The film's storyline was revealed in this review:

> Marie Empress, the clever star (appears) in one of her best productions, 'Chorus Girl and the Kid'. It tells the interesting story of one girl in love with a chorus man. He loves another and upon the money given him by the first, goes west for the consumption with which he is afflicted. After he is there for a time he sends for the second girl. A baby is born and both parents die. With great moral courage, the rejected chorus girl goes after the baby and promises to take care of it.

The next film in which Empress appeared, and one for which she is almost never credited, was *In the Hands of the Law*. Filmed in late 1916, but not released until February of the following year, *Hands* was one of the first motion pictures produced by the fledging BS Moss Motion Picture Corporation, and distributed by Balboa.

The movie, directed by Eason B. Reeves (conflicting sources say Ben Goetz), starring Frank Mayo and Louis Meredith, was a drama inspired by real events, i.e., the Stielow Case, in which a man was convicted of a crime based on circumstantial evidence. Stielow was sentenced to die in the electric chair, a fate delayed on several occasions until at last it was proven he was innocent. The plot of the movie, per *AFI*, is as follows:

> After a boy is wrongly convicted of a crime on the basis of circumstantial evidence given by his fiancée, an old man saves the boy's romance by telling of another case. The old man believed his own son to be guilty of bank robbery because of circumstantial evidence. The son's career was ruined, and he suffered a long imprisonment and died miserably.

Only the Paris-based *Bibliothèque de l'Arsenal* credits Empress's role in this film. It was probably no more than busy work for the actress, who was already slated to work with BS Moss on her next film, and who had worked with Frank Mayo in an earlier film. Given that Louis Meredith received top female billing, it is likely that Empress played a

secondary role, perhaps that of the real-life fiancée at the start of the film - the one who had her fiancé wrongly convicted. It is a likely "heavy" role for Empress, who so often played the femme-fatale or vampire.

Empress's next project in 1916 was to be a motion picture entitled *Woman Redeemed*, which was scheduled for release in December by the B.S. Moss Motion Picture Corporation. However, B.S. Moss himself made the peculiar decision to delay it so that a different film could be shown in its place. As reported in *The Moving Picture World*:

> Announcement is made by B.S. Moss, concerning a change in the schedule of his one-a-month policy - Instead of releasing The Woman Redeemed on December 1, Mr. Moss realizing that the trend of the people calls for a propaganda subject, will release a big photodrama dealing with a much discussed and popular topic. Stars of international fame will figure in the presentment.

In other words, Benjamin S. Moss, the owner of the B.S. Moss Motion Picture Corporation, had a policy of releasing only one film per month, and in order to meet the public's demand for a "propaganda" movie, release of *Woman Redeemed* would be postponed.

Woman Redeemed was released, but under another title, *The Girl Who Doesn't Know*. Empress was its star, and the "much discussed and popular topic" alluded to by Moss was female sexuality and promiscuity.

Empress was not completely absent from the spotlight in 1916, despite her hectic film schedule. Balboa decided to put on a benefit for the Actor's Fund in May at the Laughlin Theater in Long Beach.

According to *The Moving Picture World*, May 15, 1916:

> Jackie Saunders will be seen in her original travesty, "How Movies Are Made," directed by Harry Harvey. Others on the program will be Ruth Roland in songs; E. J. Brady, as "Chinatown Charlie;" Daniel Gilfether, in Shakespearean readings; Reaves Eason in a monologue. Additional contributions will be made by Marie Empress, Roland Bottomley, R. Henry Grey, William Conklin, Mollie McConnell and Alice Maison.

THE MYSTERIOUS MISS EMPRESS

THE EVER-ENERGETIC EMPRESS DID NOT RESTRICT HER ACTIVITIES to movies in 1916. She concluded the year with a new stage act at the Garrick Theatre in Wilmington, Deleware. According to the *Morning News* of that city, in an article titled *Marie Empress Act Makes Hit - Movie Star Scores Heavily in Her Vaudeville Venture at the Garrick*:

> ...it is a real classic. Miss Empress is a charming girl of graceful manner, and her wonderful talents are reflected all through this act, which is one of the big features of an exceptionally clever bill.
>
> It hardly seems conceivable to the patrons of the Garrick that this is the first week of the gifted young woman in vaudeville, but such is the case. In making up the company, for there are five in it besides Miss Empress, care has been taken to select assistants who are able supporters of the principal, and the same careful attention has been given to the preparation of the stage setting, which is elaborate, with a wealth of scenery.

10

DAMN THE TORPEDOES

On July 24, 1916, Empress returned to England and on September 2nd, graced the cover of the United Kingdom's *Pictures and the Picturegoer* magazine, bejeweled and feathered in her Firefly costume.

The magazine reported:

> Playing before the Balboa cameras in California is the great grand-niece of Edmund Keene, one of the most celebrated actors that ever trod the English-speaking stage. Her name is Marie Empress and her portrait is given as our frontpiece. Her real name is Marie Keene. Like most European artists, Miss Empress's experience before the public is varied. She has done all sorts of roles in comedy, drama, and opera, and she was a London stage favorite before going to America. Under the banner of the Famous Players she played in When We Were Twenty-one and The Firefly. The Horkheimer Brothers engaged Marie Empress to play heavy loads in their feature films, and emotional work is her specialty.

It is notable that the author of the article spelled Keane as Keene (many of his peers did the same) and mistakenly believed the Firefly

to be a movie, as opposed to the character Empress portrayed in a film.

It was not until November that Empress returned to the United States aboard the *S.S. Baltic*. This was a very dangerous time to cross the Atlantic. Though Empress had earlier lied to L.A. reporters about being stranded in America because of her family's fear of German U-Boats, the threat was real enough. German submarines did prowl the Atlantic, and no ship was immune from attack. *U-Boat 53*, as just one example, had sunk over half a dozen vessels off Nantucket by 1916 and would go on to sink 87 ships before the war was over.

The voyage of the *S.S. Baltic* from England was so dangerous that its safe arrival in New York was the subject of an article printed in the *New York Evening Telegram* on November 4th. According to that article, in order to avoid detection by the U-Boat menace, the Captain of the *Baltic* required that every light on the ship be out as it approached the coast of New York. Smokers were prohibited from lighting cigarettes on the deck.

The article's author, seeingly unfamiliar with Empress's films or reputation, nevertheless noted her presence, identifying her as "an English actress who contemplates entering the motion picture field in this country."

Nonplussed, Empress devised yet another ruse to establish her return to the United States. She disembarked and prepared to taxi to the St. Margaret Hotel at 120 West 47th Street, but as she did so, a ship's officer approached her and handed her a diamond-studded garter which she had somehow "lost" during the trans-Atlantic voyage.

A newspaper photographer was present, and Empress advised the young man that the garter had been a gift from a Duke. Then, smiling, she placed one foot on a crate and pulled the garter up a shapely leg. The photographer snapped a shot of the happy reunion that appeared in newspapers across the nation. Regrettably, the photograph was crudely touched up with brush or marker, perhaps because the original had defects. The resulting distortion of Empress's face, which looked almost caricaturish, must have displeased the subject.

The incident did get good press, though. The November 18th issue of *Billboard* provided just one of many accounts.

SAMUEL FORT

Miss Marie Empress, an English actress, lost a diamond jewelled garter presented to her by a British duke during her trip across the Atlantic. It was found by another passenger, and the photograph was "snapped" just as she was readjusting it

NEAT PRESS STORY Landed by Arthur E. MacHugh

Arthur E. MacHugh, general press representative for B. S. Moss, broke forth anew on Sunday, November 5, with an Interesting story in The New York Herald. The story, with cut of Marie Empress, star of the Moss picture, The Woman Redeemed, was drafted across two columns and well down the page. It was like this: Great consternation was caused abroad the steamer Baltic, of the White Star line, before It docked November 4 at New York, when Miss Empress exclaimed that she was unable to find a diamond Jeweled garter, which she said was a gift from an English duke. A London attorney, however, found the garter, and when it was returned to Miss Empress she deftly lifted her skirts and placed the gilded circlet it its rightful position. The cut in The Herald was conclusive proof that Miss Empress really did this.

A month later, the *Moving Picture World's Exhibitor Guide*, a large, colorful magazine that distributors provided to theater owners in order to promote their films, printed both an expensive two-page spread advertising *The Girl Who Doesn't Know* and a quarter page article on its star, Marie Empress. The article read:

Marie Empress, who has the stellar role in 'The Girl Who Doesn't Know,' the December release of the B.S. Moss Picture Corporation, is the great grandniece of Edmund Keen, one of the most celebrated

actors that ever trod the English-speaking stage. That she has inherited dramatic talent from her illustrious forbear is proved by the notable engagements she has filled on both sides of the Atlantic.

Miss Empress's real name is Marie Keene. She changed it when she first went on the stage, believing it would be well to strike out for herself since a big name is often a handicap to the beginner. At the suggestion of a friend, who called her 'Little Empress,' she adopted that as an unusual cognomen. Now, that she has arrived, Miss Empress wishes she had never switched.

This is an interesting, if unattributed, observation, and might explain why Empress briefly returned to the use of Keane (Keene) when on stage in New York, though she did eventually resume the "Empress" pseudonym. The article continued:

Like most European artists, Miss Empress's experience before the public had been varied. She has done all sorts of roles in comedy, drama and opera. As a member of some of the most famous British theatrical organizations, she was a London favorite before coming to America under the auspices of Klaw and Erlanger. Since going into pictures, a short while ago, Miss Empress has appeared with Lew Fields in 'Old Dutch.' Under the banner of the Famous Players, she played in 'When We Were Twenty-One' as 'The Firefly'.

Recently she was starred in an Equitable production entitled 'Love's Crossroads'. Miss Empress possesses a striking personality. She can endure a role with sympathy. Emotional work is her specialty. She'd rather act than eat - which describes the height of artistic aptitude, if you know anything about player-folk.

II
THE GIRL WHO DOESN'T KNOW
(1917)

> In the same audience, one person will see flickering pictures where another will not, because of the difference in the eyes.
>
> — *MOTION-PICTURE WORK*, 1915

By the start of 1917, Empress's stardom was near its peak. The previous year had been both prolific and successful, and she was now a headliner for B.S. Moss. She was so popular that *Variety* reported a "Marie Empress Club" had been created in Milwaukee. It was "a new motion picture club" with "many prominent persons socially interested. It has been called 'The Marie Empress Club,' after the screen star who is regarded as the favorite picture actress here."

The March release of *The Girl Who Doesn't Know* provided still more momentum to Empress's ascent.

In the picture, Empress played the character "Zelma," an impoverished girl who naively gets involved with (and presumably corrupted by) Paul Jerome, the manipulative and unethical owner of a gambling house. She is rescued from further corruption when the handsome

THE MYSTERIOUS MISS EMPRESS

Reverend Martin, who is preaching in the slums, saves her from suicide.

While he is caring for Zelma in his home, the two fall in love. Zelma tries to hide her past from Martin, but Jerome tracks her down and, while courting Martin's sister, reveals that he had used Zelma to lure clients into his casino. Fortunately for Zelma, Martin is not the judgmental type, and after disposing of Jerome, he asks for Zelma's hand in marriage.

Variety's reviewer, less than titillated, lamented that the film was nothing more than "straightforward melodrama of the old school," with sub-titles preaching morality for those "who prefer to have others think for them." Those subtitles included, "Ignorance is a young girl's weakness - knowledge is her strength," "Ninety percent fall through ignorance," and "If I had only known..."

As a consequence of its tepid content, the movie should have been destined for box office mediocrity. Then, as now, motion picture goers preferred titillating topics such as war, sex, and even the occult, so long as they bore the appropriate guise of morality. Films with which *Girl* competed bore titles such as, *The Sex Lure, Infidelity, Envy, The Terror, The Tiger Woman,* and *The Devil's Bait*. The hard truth was that most citizens would heartily endorse a movie promoting morality, but most wouldn't pay to see it.

And so it would have been for *Girl* had not the studio come up with a brilliant marketing strategy, which was to suggest that while the film had the objective of promoting morality among young women, it would do so by showing acts of immorality - and, of course, the consequences of those actions.

An Australian advertisement for the film described it as:

The Most Beautiful Woman in Pictures
MARIE EMPRESS

> A Daring, Frank Photo-Play Handled with Rare Delicacy. What is the Greatest SAFEGUARD to Young Men or Women Against Temptation? The Answer is KNOWLEDGE. Ignorance is a Child's

Weakness - Knowledge Her STRENGTH. See "THE GIRL WHO DOESN'T KNOW."

An American promotion read:

Purity, Innocence and Sweetness can never take the place of knowledge. 'The Girl Who Doesn't Know' - The Most Sensational Movie Ever Made. Teaching young girls the physiological facts of life has resolved itself, under modern living conditions, into one of the holiest duties parents have to perform. That such information can be imparted in an earnest, wholesome manner is proved by this screen-play itself. So surely a girl's best friend, her Mother, can give this vital knowledge to her chastely and with dignity. As many fail to realize these facts, this photoplay is dedicated to them in the hope it will make them seriously consider the problem it treats of - so they will study its various phases and PREVENT disaster - not deplore it after it is too late. MOTHER, does your girl know? THIS PICTURE IS BOLD - BUT IT IS TRUE - THE LITTLE GIRL MAY BE ANY LITTLE GIRL.

To make the film more tantalizing, advertisements often included a photograph of a robed Marie Empress reading a book. The caption was, "The World's Most Beautiful Woman."

The implication was that *Girl* would show young, chaste daughters everything they needed know about "the physiological facts of life", i.e., sex, in a "frank" and "direct" manner.

The promotion successfully lured into theaters thousands of viewers who were not, in fact, mothers or daughters. Few men could resist that much bait.

Girl was a hit. The film was so successful that it was still showing in theaters as late as 1922, five years after its initial release.

Paying homage to the studio's marketing strategy, the same *Variety* reviewer who derided *Girl* for its preachy morality reluctantly acknowledged that the film possessed "one of the most attractive titles, from a box office standpoint, that could be conceived," and that, though the movie's title and advertisements were certain to appeal to the less-

noble motives of many ticket-buyers, the film was essentially immune to censor because its ostensible goal was the safeguarding young girls' chastity.

> The exhibitor...can play it up for a freak engagement without the slightest fear of molestation from the authorities." In fact, an exhibitor would probably be able to draw support from "prominent people connected with uplift societies.

In Quebec, the censors thought differently. They refused to allow it to be shown, stating that the film was "not in good taste" and included as a plot point, "the sex question."

In a trivial but interesting side note, the *Desert News*, March 17, 1917, reported that *Girl* used the most expensive prop ever purchased for a motion picture up to that time. It was a painting by Rembrandt, *Portrait of a Man*, and was purchased by William A. Clark for inclusion in the film at a cost of $130,000.00.

※

WITH THE SUCCESS OF *GIRL*, EMPRESS WAS IMMEDIATELY OFFERED A role in another movie titled *The Girl Who Wouldn't Marry*. However, Empress was not content to be merely a moving picture star. She had plans to produce a new vaudeville show, which she alone would control. In March, Empress paid for a large, boxed classified advertisement in *Variety* that read:

<div style="text-align:center">

WANTED
Immediately by
MARIE EMPRESS
FIRST CLASS PIANO PLAYER
Who Can Lead the Orchestra
Apply MARIE EMPRESS
St. Margaret Hotel, West 47th St., New York. Phone, Bryant 617

</div>

Just a few weeks later, however, it appeared Empress might have to forfeit both vaudeville and film to join the war effort.

In January of 1917, Germany had announced it would destroy all ships heading to Britain from the United States. Though that wasn't enough in itself to bring America into the war, President Wilson ended diplomatic ties with Germany and began arming merchant vessels. True to its word, Germany began sinking American ships immediately, and on April 2nd, just two weeks after Empress had placed her ad for a piano player, America declared that it was at war.

British performers who had remained in the United States even after England went to war were now given even greater impetus to return. Many left for their homeland immediately, so it was no surprise when, in April, *Variety* reported:

> Marie Empress denies the report that she is to return to pictures [a reference to an earlier report that she had would make a new feature called "The Girl Who Wouldn't Marry" for a new film concern]. She has contributed her services as an English Red Cross nurse and sails for London in about ten days to take up that work.

The report was premature. Empress did not leave for England that April. Instead, she hired a man named Con Conrad to be her pianist, and the two worked up a new vaudeville act, which premiered in June.

Variety, June 9:

> Con Conrad, formerly Conrad and Whidden, is the accompanist for Marie Empress.

The act opened at Newark for three days, but was held over for the week on account of the success registered.

A *Variety* review of the new act:

> Marie Empress has returned to vaudeville in America after an absence of about six years. Her previous venture lasted but two weeks, the first being at Young's Pier, Atlantic City, and the second at Hammerstein's. On both occasions, she headlined the bill, but more because of her

THE MYSTERIOUS MISS EMPRESS

wonderful advance publicity campaign rather than anything else. At the time Miss Empress was a new arrival from England, where she was said to have been a favorite in the Halls.

Since that time Miss Empress has devoted herself more or less to appearance in pictures, having been featured in vampire roles in several of the bigger productions. Her return to vaudeville is marked by the fact that she is carrying a group of four assistants. Con Conrad is at the piano for the four numbers done, and in addition plays piano bits by himself. The other three assistants are used to lend a comedy finish to the act and this they do with a vengeance.

Of the selections that Miss Empress sings the first is the worst and should be cut immediately. It is supposedly a French soubret song, but Miss Empress doesn't get it over.

The second, after a change, is a song about 'Mary' who came from the country and went into the films and finally married the director, after which she wished that she was back on the farm again. It is clever and rather well put over.

The third number finds the star offering a male impersonation in evening clothes. She is a good looking and smart appearing "boy" of the English Johnny type. Her number for this is one about the vagaries of the English language as spoken in this country, touching particularly on the slang expressions. This number can be worked up to a hit with a little more application.

The final number is with Miss Empress as a "boy" at the seashore, not much at first, but when the three different types of bathing girls are brought in there is a howl of laughter from the audience. The first is a dainty appearing blonde, rather cute; the second a girl of Charlotte Greenwood proportions, and the third (who also appears to be a girl at first) could easily apply for the job of fat lady with the B. & B. show. The final comedy jolt is the disclosure that the stout person is a female impersonator. The act looks good enough to be worth featuring, after the opening number is eliminated and something of greater strength substituted.

Such approval was not universal, however. According to another account:

Miss Empress was the headliner, and the gallery booed her. Catcalls accompanied one of her songs. The song was melodious and the singer was rarely (i.e., unusually) beautiful, but the gallery disapproved of her love scenes with her pianist, Con Conrad. It thought them too realistic. The curtain was rung down. The pianist and the piano were moved below the stage, and Miss Empress resumed her songs.

On October 17th, Empress finally sailed back to England aboard the *S.S. Lapland*. But Empress had one last, great performance for the world. And it would be a doozy.

Still shot of Empress from The Girl Who Doesn't Know

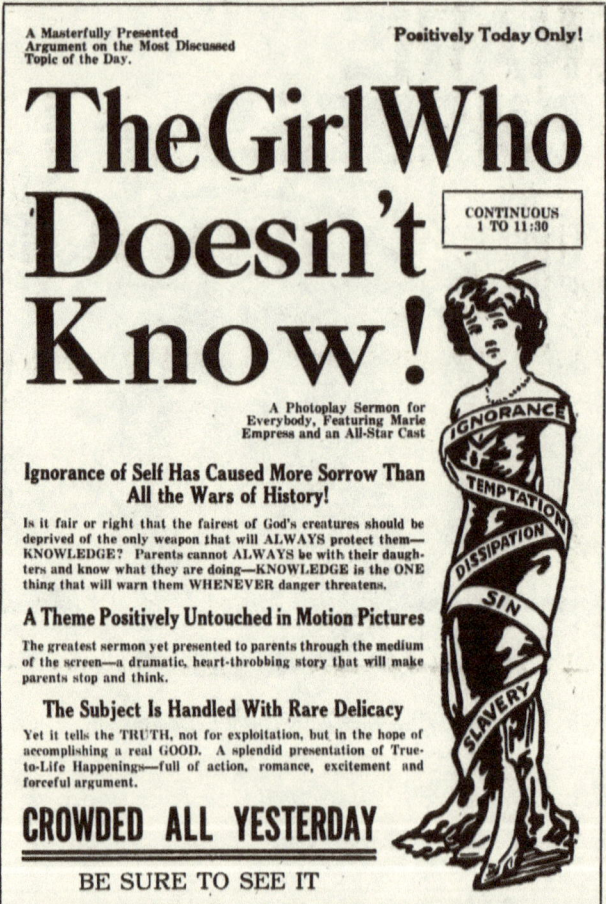

An advertisement for The Girl Who Doesn't Know

12

THE HALIFAX JOURNEY (1919)

>Tonight we fill and raise the glass
>Tomorrow it drops and smashes,
>Tonight we burn with joy, alas!
>Tomorrow we wear the ashes!

— LYRICS FROM *THE LITTLE CAFE* (1913)

On October 16, 1919, five months after the signing of the Treaty of Versailles, and over two years since Empress return to England, the actress again set sail for New York.

She sailed aboard the *Orduna* of the Cunard Line, a three-screwed, 17-knot, 15,500-ton passenger ship that provided trans-Atlantic service between the United Kingdom, Canada, and the United States. The ship had accommodations for 300 First, 350 Second, and 450 Third-class passengers, and provided those passengers with spacious decks (to include glass-enclosed promenade decks), a gymnasium, and a veranda cafe.

SAMUEL FORT

S.S. *Orduna*

The ship's Captain, Thomas M. Taylor, had been the master of the *Orduna* since it was built in 1914. Born in Scotland in 1860, Taylor was what is euphemistically called "an old salt," having served at sea since he was 19 years old. The *Orduna* had won fame early in its life by being the first newly-built steamship to travel from England to New York after the outbreak of the Great War, despite the ever-present danger of patrolling German submarines. In 1915, a German submarine would intercept the ship and launch torpedoes at it, but none hit their target. Another ship of the Cunard line, the *Lusitania*, was not so lucky.

When it left Liverpool, the *Orduna* had 850 passengers aboard in addition to a crew of 325. The itinerary called for the ship to travel first to Halifax, Nova Scotia, where it would stop briefly to unload some passengers, mail, and cargo on the 25th. From there, it would make a two-day voyage and dock in New York the afternoon of the 27th.

Empress was given Stateroom 480, a First-class cabin on the "B" deck, also known as the *awning* or *hurricane* deck. The room was smallish but certainly acceptable for a ten-day journey. Brightly painted wood panels covered the cabin's metal walls and the floor was carpeted. On one side was a twin bed with an iron rail headboard and a steel safety rail that could be used to stop oneself from falling out of bed if the ship began to roll in bad weather. A metal shelf was built into the wall above the bed for storage of a few personal belongings.

An identical bed and rack were on the opposite wall, but this bed had at its foot a small closet.

A sink was built into the center of a third wall, opposite a wardrobe. High on two of the walls were 13" wide rectangular portholes. An electric fan was mounted high on one wall, also.

A corridor outside the stateroom led to several ornately decorated salons where passengers could socialize, read, drink, smoke, or watch the ocean through the salon's windows. These rooms were well appointed with chairs, tables, and electric lights, and offered a wonderful view of the ocean. If someone wished, they could exit the salon to the railed awning deck, and from there take stairs down to the main deck.

* * *

Bizarrely, Empress wore only black dresses, hats, and veils during her voyage to the United States. An explanation of the mourning dress is elusive, but there are circumstances that will be discussed later that might shed some light on this particular oddity.

The voyage across the Atlantic was uneventful. The *Orduna* docked at Pier 2 in Halifax shortly after noon on Saturday, October 25th, and there landed 150 passengers and a few bags of mail. Empress went ashore briefly to wire a message to a hotel in New York in which she had once lived. It read simply, "Arrive Monday. Please have room for me."

The actress then returned to the ship, where she and approximately 700 other passengers prepared for the final leg to New York. Among her fellow travelers were many notables, to include Spanish delegates to a major industrial convention in Washington, headed by His Excellency Don Luis M. Visconde de Eya; Sir R.F. Stupart; Sir Johnston Forbes Robertson and his wife Lady Robertson (Sir Robertson was traveling to the United States to deliver lectures on Shakespeare); and Lieutenant "Matty" Smith, an Australian Flying Corps "ace" and lightweight boxing champion, on his way home to Racine, Wisconsin.

While the ship was docked in Halifax, Empress passed the time in one of the ship's First-class lounges. She wanted to purchase cham-

pagne, which she said helped her overcome seasickness, but no spirits were served while the ship was in port.

When it finally pulled away from Halifax between 3:30 and 5:30 p.m., just a few hours after it had arrived, she pulled a large roll of British pounds and American dollars from her gold mesh bag and obtained the medicinal spirits she sought. As she sipped her bubbly, the *Orduna* headed south toward New York. With the long voyage across that Atlantic complete, this last leg of the journey should have been inconsequential.

Surely it would have been, had Marie Empress not vanished into thin air.

13

NOW YOU SEE HER...

Geraldine: I love the sea, and never am ill on it.
Tillbury: And on the land?
Geraldine: I never am ill on land, either!
Tillbury: Really! What a beastly healthy person!
Geraldine: Oh, do hit some wood quick or my luck may change!

— SCENE FROM *THE STUBBORNNESS OF GERALDINE* (1906)

There are two primary accounts of what Empress said and did on the evening of her disappearance, and what happened the morning after.

The first was given by a steward, Samuel Furnell. The 55 years old was, like most of the *Orduna's* crew, a Liverpool native. He attended to passengers in B deck's staterooms, to include No. 480. What follows is his brief account of what transpired on the evening of the 25th and morning of the 26th, as revealed by the *New York Tribune* on October 28th:

She (Empress) called me at 6:30 p.m. on Saturday (the 25th), an hour

after we had left Halifax. She asked for a glass of water, and with a smile, thanked me when I brought it. She had been in the habit of eating a few sandwiches and taking a cup of tea about 10:30 every night, but Saturday night there was no call from her room. I knocked at the door at 10:00 Sunday morning, and, getting no response, opened the door. Miss Empress was not there, and her bed had not been disturbed. When she did not come to luncheon we started a search.

According to the steward, Empress had appeared on deck daily and had talked to passengers whom she had met while dining. He said she always appeared in black and that she was "conspicuous" by the constant use of a monocle.

* * *

The second account of Empress's actions and words was published several weeks later in a somewhat sensational full-page feature, *The Mystery of Stateroom 480*.

According to the article, reporters who boarded the *Orduna* when it docked in New York were met at Empress's cabin by a stewardess whom they described as an old, thin woman with gray hair. Her name was not given, but the most likely candidate is Margaret Farley, then 59 years of age and 5'1" tall.

As reporters peered into Empress's cabin, the stewardess told them that she and the missing actress had grown close as the *Orduna* traversed the Atlantic and that they had enjoyed many conversations, though most were trivial.

She vividly recalled her first encounter.

"She was dressed in black, with a little hat and a big veil, all black. I thought she might be a war widow. I said, 'Are you Miss or Mrs.?'"

Empress answered, "I have never married, but I may soon."

The attendant said, "That's nice if you marry the right one."

"That's so, if you marry the right one," replied the actress.

The older woman also reported that Empress was concerned about where she would stop in New York. She quotes Empress as saying, "I really haven't any friends there and I don't know where I'll stay."

THE MYSTERIOUS MISS EMPRESS

To which the attendant replied, "There are plenty of fine hotels. And the taxicabs will take you right there."

"That's true," Empress said.

The stewardess told reporters, "Lots of ladies have talked that way to me before landing. She said once that she hadn't been very well. There was a little mark, a red line that ran straight across the side of her nose. She said she had got hurt in an automobile accident."

"When I get to New York, I'm going to a hospital to be treated for it," Empress told her.

"She seemed cheerful enough," the stewardess added. "She would make little jokes while I sowed the rips in her clothes. We had several laughs together about things I've forgotten. She seemed just like any other lady who was making the crossing, except that she was better looking and better humored."

At 6 p.m. on the 25th, two and a half hours after the *Orduna* left Halifax, the stewardess knocked on the actress's door and asked her if she wanted anything to eat.

"I don't feel well and don't believe I'll take anything," the actress answered.

The stewardess insisted she should eat, however, and Empress acquiesced, saying, "All right, a little bit of chicken."

The stewardess brought her the chicken on a tray and came back later to find the tray empty. "You did eat it, then?" she asked.

"Yes, thank you, it was very nice."

"Will you have sandwiches for the night?"

"Yes," was the reply.

The stewardess then turned down the actress's bed and left.

* * *

At 9:30 p.m., the attendant returned with the sandwiches, but Empress was not in her room, so she left the sandwiches for her.

At this juncture, newspaper reports of the stewardess's narrative differ slightly. One version was that after leaving the sandwiches, the stewardess did not return to the stateroom until the next day, while another held that the stewardess returned several times after delivering the sandwiches in order to bid Empress good night, but that the actress was never there.

83

All reports agree that it was not until the following morning that the stewardess, having again knocked and receiving no reply, entered the room and found it unchanged from how she had left it the night before. The sandwiches were still there, and the actress's bed had not been slept in.

Concerned, the attendant went to the ship's captain and told him of Empress's prolonged absence. The captain shared the old woman's concern and immediately ordered three stern-to-bow searches with orders to locate the errant passenger.

The stewardess, finishing her tale, nodded in the direction of the stateroom. "And the room was just as you see it now."

The reporters found nothing unusual about the room but did note that stacks of Empress publicity photographs had been placed on a shelf on one wall. Undoubtedly, they liberated some of them at the interview's conclusion.

A slight variation of the stewardess's actions was reported by the *New York Herald*. Its reporter claimed that she reported Empress's disappearance not to the captain, but instead to the chief steward, Robert Chisholm, who, in turn, notified the purser, J.M. Ekins. According to the *Herald*, it was Mr. Ekins that finally relayed news of the disappearance to Captain Taylor.

It appears that both a steward and the stewardess waited on Empress. Most likely, stateroom 480 was Sam Furnell's responsibility. Still, the older woman, the stewardess, had struck up a relationship with Empress while patching up some of her clothes and had taken it upon herself to serve the actress the occasional meal.

There is no reason to doubt Furnell's claim that, on the evening she disappeared, Empress had called the steward and asked for a glass of water. He delivered it and carried on with other duties.

Almost immediately after he left, or possibly just before (both events were said to occur at around 6 p.m.), the stewardess appeared and offered Empress something to eat. The actress declined but was eventually convinced by the stewardess to accept some chicken. The

attendant promised to come back with sandwiches later, to which Empress also consented.

This might explain why Empress did not call the steward to request sandwiches at 10:30 p.m., which he said was her habit. If the stewardess had already promised to bring sandwiches, Empress would not need the steward to do the same. Of course, it is also possible that Empress was already missing, which is why she neither ordered sandwiches nor consumed the ones brought to her.

PASSENGERS AND CREW MEMBERS AGREED WITH THE STEWARD AND stewardess that Empress spent the entire voyage dressed in black, though she dined with other passengers on occasion, and everyone aboard found her to be in high spirits.

They also reported that during most of the *Orduna's* stay in Halifax, Empress sat at one of the ship's bars for "several hours." She wanted to purchase champagne, but the bar was required to remain closed while the ship was in port.

When the *Orduna* pulled out of port, and the bar was reopened, the actress purchased a bottle of champagne for five pounds, which she withdrew from a gold-mounted bag that dangled from her wrist. Some of the witnesses saw the bag opened and observed that Empress was "well supplied." It was also reported that Empress had hardly touched a drink while at sea, and was practically a teetotaler with the exception of the champagne.

14

...NOW YOU DON'T

> Hearts for girls
> Are not nearly such useful things as pearls
> Send your heart, my dear, to the bottom of the sea!
>
> — LYRICS FROM *THE LITTLE CAFE* (1913)

Putting aside the question of whether it was the steward or stewardess who discovered Empress missing, we know that by mid-day on October 26th, Captain Taylor ordered his crew to conduct three bow-to-stern searches for the missing passenger. When the last search was completed, Marie Empress had still not been found.

The situation was reported to port authorities as well as the British Consul General by wireless telegraph. The *Orduna* arrived in New York the following day, October 27th, and anchored at Pier 54. Empress's baggage, which consisted of several pieces of hand luggage and five trunks, was unloaded to the dock. The contents of all the bags and trunks were examined by investigators. Inside they found a few articles of men's clothing, which was initially deemed unusual, as Empress was unmarried and unaccompanied on the voyage. Investiga-

THE MYSTERIOUS MISS EMPRESS

tors ultimately decided that Empress used the clothes in her male impersonations.

More intriguing was the absence of any jewelry in Empress's belongings. Empress was famous for her extravagant displays of glitter, so it was inconceivable that the Englishwoman would have traveled with none at all. Also missing was her handbag, the gold-mounted one that had been spotted by several of the ship's passengers while the ship was in port in Halifax.

Orduna's officers reportedly found Empress's passport, and, according to a single report, it contained a very odd bit of information. It had not been issued to Marie Empress, of course - that was merely a stage name. However, it had not been issued to Marie Keane, either. It had, instead, been issued to a "Miss M. A. Smith," with the addendum, "professionally known as Marie Empress."

The ship's officers, apparently unaware that Empress's actual surname was supposedly Keane, did not question the name on the passport. Neither did investigators or reporters. Amazingly, no one publicly questioned why the passport was issued to Marie Smith and not Marie Keane. Presumably, the reporters who knew that Empress's surname was allegedly Keane took no notice of the single report regarding the found passport, and the report was written by a journalist who did not know that Empress's true surname name was supposedly Keane.

The ship's Captain, unable to explain the performer's disappearance, wrote a note to the left of Marie Empress's name on the ship's manifest: "Supposed Suicide."

On that same manifest, completed in Liverpool, England, before the journey began, the actress had provided the following information:

Given Name: Marie Empress
 Yrs: 35
 Mos: 7
 Married or Single: S
 Calling or occupation: Artiste
 Read: Yes
 Read What Language: English

87

SAMUEL FORT

> Write: English
> Nationality: England
> Race or people: English
> Last permanent residence: England
> City or town: London
> Final Destination state: N. Y.
> Final Destination city or town: New York

The name and complete address of nearest relative or friend in country whence alien came: Mr. Oliver Williams (friend), 116 Victoria Street, London. The word "friend" was written in ink above Williams' name.

15

THE MYSTERY OF STATEROOM 480

No more trace of her was found than if she had been dissolved into thin air and wafted out thru a ventilator.

— *NEW YORK REPORTER*, NOVEMBER 7, 1919

Within hours of the *Orduna*'s arrival in New York, newspapers were reporting the disappearance of Marie Empress. Additional stories were published in the days that followed, as more details were made public.

Examples:

ACTRESS DISAPPEARS FROM CUNARD LINER
 Marie Empress Was Passenger On Orduna - Search Fails to Locate Her
 NEW YORK. Oct. 27 - The disappearance of Miss Marie Empress, a London music hall singer, on the high seas while on her way from Liverpool to New York, was learned here with the arrival of the Cunard liner Orduna from the English port. Miss Empress .was last seen at. 6:30 Sunday evening when, a steward brought, a glass of water to her cabin. Search of the vessel failed to give any clew to her

89

disappearance. Her effects will be turned over to the British consul general.

ENGLISH COMEDIENNE DISAPPEARS OFF SHIP, NO TRACE IS FOUND

NEW YORK, Oct. 28 - Sometime between 6.30 p.m. Saturday and 10 a.m., Sunday, Marie Empress, the popular English comedienne, disappeared from the Cunard liner Orduna, while the vessel was on her way from Halifax to this port. A general search of the ship failed to find her, and it is presumed that she drowned. There were travelers on the Orduna, however, who doubted this as they had found Miss Empress to be in good spirits throughout the trip from Liverpool to Halifax. A vigorous search of the vessel today failed to give any clue to her disappearance. Her effects will be turned over to the British Consul General.

ENGLISH ACTRESS DISAPPEARS AT SEA

November 4 - Disappearance of Marie Empress, English vaudeville actress from the steamer Orduna as it approached New York is still a mystery. The young woman is believed to have fallen or jumped overboard, but no cause for suicide has been revealed.

ACTRESS LOST ON SHIP

Marie Empress of London Disappears In Sea Between New York and Halifax.

NEW YORK, Nov. 7 - The latest ocean puzzle centers between Halifax and New York. The heroine is a young English comedienne, Marie Empress, who disappeared from the Cunard liner Orduna a few hours after the vessel had left Halifax for New York. She was seen in her stateroom early in the evening when the ship was an hour out of port and nobody on board admitted seeing her leave it, when the steward unlocked the door next day after she did not respond to calls or appear at the luncheon table, table. Her bed had not been slept in and she had not called the steward for the lunch she had been in the habit of eating about 10:30 p. m. since leaving Liverpool.

Miss Empress, who had played two long engagements in America

THE MYSTERIOUS MISS EMPRESS

and presumably was on her way to sign a third contract, was always cheerful when she came in daily contact with other passengers on the ship. Never had she intimated that tragedy might overtake her. And, so far as her fellow travelers know, she left no note of explanation among the several pieces of hand luggage and five trunks which were turned over to the British consul at New York without examination by the American customs officers. The ship was searched thoroughly as soon as Miss Empress was missed, but no more trace of her was found than if she had been dissolved into thin air and wafted out thru a ventilator.

TWO WEEKS AFTER HER DISAPPEARANCE, IN MID-NOVEMBER, newspapers across the nation ran a full-page feature story on Empress's vanishing, complete with numerous photographs and an artist's rendering of Empress in formal dress casting herself into the sea. This feature, which was given the title *The Mystery of Stateroom 480*, carried a Great Britain copyright, so presumably it was written in the United Kingdom and then sold to newspapers in the United States.

That it was written in England would explain the author's erroneous assumption that Empress was unknown to Americans. The writer clearly had no idea that Empress had spent most of 1910-1919 on stage or making films on both the east and west coasts. Empress's unfortunate first outing at the Victoria is recounted in the feature, yet nothing is said of her successful career as an actress in the nine years that followed. In fact, the writer of the piece seems to have believed that the 1919 voyage was Empress's first trip to the U.S. since 1910.

Much of the feature is simply fluff, or, more kindly, poetic ruminations that provide no useful information. For example:

> Even on the greatest of ships, surrounded by his kind, man feels the immensity about him. And it is, probably, the recognition of the vast distances, the appalling power against which a man's strength is like the beating of a fly's wing in the tempest that sots a disappearance at sea is a thing apart from all others.
>
> What was it that reached out of the great waters and plucked Marie Empress from the liner? What subtle, spell - what promise of surcease of sorrow - came from the black and racing waves that night luring her to death in their icy arms?

Edmund Keane would have likely approved.

One motive for suicide was that Empress was so traumatized by her bad performance at the Victoria in 1910 that she would rather kill herself than possibly repeat such a horror.

> Did her courage fail her when within a day's sail of the city she hoped to conquer? For once she had failed there...could it be that, thinking of the past, she felt the battle before her to be too great, and in a moment of weakness and depression cast herself away?

This explanation had no merit, of course. Empress had spent most of the past decade in New York. Since her appearance at the Victoria in 1910, the actress had enjoyed a string of successes on stage and in movies in the United States. She had socialized with the rich and famous, relaxed at the best hotels, and attended prestigious East Coat dog shows.

A few paragraphs later the reporter offers a more reasonable motive for the actress's alleged suicide: drug addiction.

> It is said by friends that during her first American tour Marie Empress fell violently in love with a musician in New York. After the partial, at least, collapse of her ambition the circumstances preyed so upon her mind that she sought forgetfulness in drugs. Soon after this came a parting between her and the man loved. The drug habit was not broken, it is said.

THE MYSTERIOUS MISS EMPRESS

The suggestion that Empress was a drug addict as well as a scorned lover, and that she killed herself as an escape from a personal hell, is one which most modern readers will find entirely plausible. Newspapers and magazines today are awash with similar stories of drug-addicted celebrities who cannot deal with failing careers or failing relationships and who end up killing themselves. Could this be what happened to Marie Empress?

As for the accusation regarding drug use, there were certainly plenty of drugs to be had at the time, often legally, and many performers used them. We are told, anecdotally, that Empress once tried to kill herself as a young woman, so possibly she suffered from some form of depression and used drugs to pick herself up.

As to the report that the Englishwoman had once fallen violently in love with a musician from New York who abandoned her after she started using drugs - who would that be? Con Conrad, the musician, perhaps? Was he the man with whom her love scenes were so realistic that she was the subject of boos and catcalls from the audience? Yet that was in 1917, two years prior, and their parting appears to have been caused by her need to return to England after America announced war on German - not a lover's quarrel.

WHEN NONE OF THE ACTRESS'S FABLED JEWELRY OR HER PURSE could be located, reporters theorized Empress had not killed herself but had been murdered by a thief that was drawn by her jewelry and purse full of cash. Still another theory was that a jilted or would-be lover had murdered her in a fit of rage.

But no one on board the *Orduna* reported seeing Empress with a man, and no one witnessed Empress in any arguments or fending off male advances. No one acted suspiciously when around the actress.

Was it possible that she might have gone to the rail to get some fresh air, and then somehow fell into the ocean by accident?

This is a simpler solution than suicide or murder, but it is far from perfect. Empress had sailed between England and America at least seven times, and between England and South Africa at least twice, thus

traversing the Atlantic a minimum of eighteen times. She would have been very conscious of the danger of leaning too far over the rails. The ship was traveling in calm waters, so there was no unusual rolling or pitching that would have made her presence on the deck any less safe than normal. No one so her fall from the ship, or heard a splash, or screams for help, despite the fact that the decks were lighted and many passengers were lingering above the ships rails.

Besides, there were certain oddities that suggest Empress's disappearance may not have been accidental. These will be discussed in the chapters that follow.

16

HOT, THIN AIR

> But how did he leave? How did he escape? If no trap, no secret door, no hiding place, no opening of any sort is found; if the examination of the walls—even to the demolition of the pavilion—does not reveal any passage practicable—not only for a human being, but for any being whatsoever—if the ceiling shows no crack, if the floor hides no underground passage, one must really believe in the Devil, as Daddy Jacques says.
>
> — *THE MYSTERY OF THE YELLOW ROOM,* GASTON LEROUX

Despite the official proclamation of suicide, almost no one believed that Marie Empress had killed herself. Not her friends, not her fellow passengers, and not the crewmen of the *Orduna*. Reporters were skeptical from the start, as were their readers.

The stewardess who supposedly befriended her spent a great deal of time with her and reported no odd behavior or signs of drug use. To the contrary, she found Empress very good company.

"She seemed cheerful enough," the stewardess had said. "She would

make little jokes while I sewed the rips in her clothes. We had several laughs together about things I've forgotten. She seemed just like any other lady who was making the crossing, except that she was better looking and better humored."

In fact, everyone on board the *Orduna* found the actress jovial and good company. She joked with the stewards, dined with her fellow passengers regularly, and attended a dance the night before the *Orduna* docked in Halifax.

Passengers, it was reported, did not accept the suicide theory because they "had found Miss Empress to be in good spirits throughout the trip from Liverpool to Halifax."

"She was exceedingly attractive," said another reporter, "alone, and so far as any of her fellow passengers could see, untroubled."

"Never had she intimated that trouble might overtake her," said another.

"No cause for suicide has been found," said yet another.

And another: "No one on board believes the suicide theory."

The *Evening Public Ledger* of Philadelphia summarized the sentiment as follows: "None of the officers of the *Orduna* could throw the slightest light on the disappearance of Miss Empress and none of the passengers could give a clew to the mystery. All agreed that she had not shown a single despondent sign during the voyage."

The actress was making preparations for her arrival in New York the day before she vanished, having wired ahead to reserve a room and having laid out publicity photos for distribution to reporters. This would be odd behavior for a woman planning to throw herself into the sea a few hours later.

Walter Haster, a Manchester, England expatriate who produced and directed several English and American plays in New York from 1914 to 1924, knew Empress. When interviewed, he immediately dismissed the suggestion of suicide, saying, "She was too young and lovely to have sought such a death of her own will."

Mental station and motivation aside, there were logistical problems with the suicide theory. The actress disappeared sometime between 6 p.m., when the steward and stewardess claimed to have last seen her, and midnight. She neither ordered sandwiches at 10:30 p.m., nor ate

the ones brought to her at 9:30 p.m., nor went to bed at any point that evening. When the stewardess entered her room at 9:30 p.m., it was empty.

No one aboard the *Orduna* saw Empress outside her stateroom during this span of time, either. This is unusual because those three and a half hours were "prime time" for passengers aboard the *Orduna*. This was 1919. There were no televisions or radios in the staterooms. The ship was just a night's voyage from New York and many if not most of the passengers aboard would have used this last evening to loiter on the decks, sipping drinks and smoking cigarettes as they cemented their new friendships, bid each other farewell, and made plans for the first day ashore in America.

According to the *Daily Kenneber Journal*, of Augusta, Maine, not far distant from Halifax, the skies that day were partly cloudy to cloudy, but rain was not expected until Sunday. Sunset occurred at 5:41 p.m. Of particular significance is the freak weather pattern that was pushing warm air up from the Southwest, making October of 1919 one of the hottest on record for the region. The *New York Times* reported that on October 28th the mercury had hit 81 degrees in New York, a record for late October. Boston also saw a record, at 78 degrees.

The *Orduna*, just a day's sail from New York, was caught in the same heat, and this in an era before air conditioning. Few passengers would wish sweat in idle misery in their steel-walled cabins with only a fan and tiny porthole for ventilation when the deck offered fresh ocean breezes and good company.

Consequently, the decks of the *Orduna* were busy the evening Empress disappeared. Yet, no one saw her outside of her stateroom. The *Mystery of Stateroom 480* fairly assesses this perplexity:

> How, from this well-lighted, carefully-watched ship, could she vanish without a single living soul having seen her? To reach the awning deck, Empress traveled down several passageways, through several salons, always at least half filled, and the actress was of sufficiently striking personality not to have been able to slip through unobserved. To gain the decks she would also have had to pass by various stewards and officers, and, finally, having gotten there, it seems almost, impossible

that she could have slipped unnoticed to the rail and thrown herself over. All the decks and promenades are brilliantly lighted until long past the hour when she must have disappeared from the ship.

Here enters the first element of the mystery of Stateroom 480. How did Marie Empress leave the ship?

17

HOAX?

By many names men call me -
Press agent, publicity promoter, faker;
Ofttimes the short and simple liar...
Every one loves me
When I get his name into print -
For this is an age of publicity
And he who blowest not his own horn
The same shall not be blown.
I have sired, nursed and reared
Many reputations...
I hold a terrible power
And sometimes my own moderation
Amazes me.

— *LO, THE PRESS AGENT*, WILLIAM J. KINGSLEY

There were numerous theories regarding how Empress might have faked her suicide. The earliest was that a boat had intercepted the *Orduna* at a pre-arranged destination, and that Empress, probably in disguise, had managed to board the boat in

the cover of darkness without being observed. She was then presumably spirited ashore, where she would stay in seclusion for a few days, allowing public tension to build. Then, with perfect dramatic timing, she would miraculously reappear, basking in the publicity that her survival would generate.

This was a very plausible scenario. Empress was a tireless and creative self-promoter, and Walter J. Kingsley was a shameless publicist. A faked suicide and staged rescue would, by all accounts, be exactly the kind of stunt both would entertain if it garnered coverage by the newspapers. Empress had been out of circulation for almost three years. It was possible, even likely, that her arrival in New York would go unnoticed by reporters if Empress and her agent did not find a way to generate publicity.

Adding credence to this theory was the fact that the entertainer did not elect to jump overboard as the *Orduna* crossed the Atlantic. Instead, Empress allegedly leaped into the water as the ship sailed between Halifax and New York.

Also, consider the statement made by Samuel Furnell, the *Orduna* steward, that Empress had appeared on deck daily, always appeared in black, and was somewhat conspicuous by the constant use of a monocle. In a surviving photo of Empress cross-dressed as her male character "Chappie," a monocle can be seen attached to a lanyard that hangs around her neck. Empress used the iconic eyepiece as a prop because, like canes, top hats, and cigars, it identified Chappie as a gentleman of a certain station. During her Chappie routine, Empress may have swirled the monocle in front of her, occasionally raising it to an eye to accentuate a punch line.

Though no one voiced suspicions at the time, the monocle that Empress used aboard the *Orduna* may have been the one she used in her Chappie act.

Among other things, this would explain why Furnell called her use of it "conspicuous." Empress did not need the eyepiece and so did not use it in a natural manner. She used it too much and at inappropriate times. Non-smoking actors in modern films often make the same mistake when their roles require them to pretend to smoke cigarettes. They will hold the cigarette in an unnatural manner and will tend to

raise and lower the cigarettes far more frequently than a real smoker would. They will stub out a cigarette that was lit only a moment before, and their puffs are usually either too shallow or too exaggerated.

If the monocle was a prop, it is conceivable, even likely, that the widow's outfit was a costume. Could it be that Empress was starring in a one-woman play and that the *Orduna* was her stage? Might her role have been that of a grieving woman who, despite a brave, good-natured veneer, was so burdened by the loss of a loved one that she was capable of suicide?

There is also the fact that reporters who interviewed the old stewardess when the *Orduna* was docked in New York found publicity photos of Empress readily available on a shelf in the missing woman's cabin. None of the photos had been handed out during the voyage to other passengers; they were clearly meant for reporters. Did Empress intend them for reporters on the docks when she alighted safely in New York, or were they carefully placed in plain view for those reporters who would inevitably be drawn to her cabin after her disappearance? Was the availability of the photos perhaps too convenient?

The American public was not alone in its suspicions of deception. In November, *Variety* reported that in London, "The Marie Empress suicide story is believed here to have been a publicity stunt."

18

A THIEF IN THE NIGHT

Some accepted that Empress had faked her death, but theorized that the actress had not needed a boat from shore to make her escape from the *Orduna*. Instead, she had concealed herself after the *Orduna* departed Halifax, alighting from the ship unobserved - probably in disguise - when it docked in New York.

"Maybe she was a stowaway," suggested an *Orduna* Petty Officer to reporters. "She could have slipped into men's clothes and hidden in the hold. There were men's clothes in her belongings. Maybe she got tired of a woman's life and thought she'd try a man's for awhile. She could pass as a man without any trouble. She'd been a male impersonator."

Some of the sailors aboard the ship were adamant that they had seen Empress in "the grimy jeans of a fireman." Others claimed to have seen in her in a sailor's uniform. Many crew members suspected that Empress had used one of these disguises to sneak off the *Orduna* after the ship anchored in New York.

The "alighted in disguise" theory was gospel for many reporters. An unnamed reporter for the *New York Clipper* was so enraged that Empress's death had been classified as a suicide that he insisted that the U.S. Government punish Empress for her antics when she eventually revealed herself. In an article titled *Marie Empress May and May Not*

Have Disappeared, the writer took special note of the way the actress's luggage was handled after she disappeared, and what that handling implied.

> The United States Customs officials, as well as those connected with the Immigration Bureau, are investigating the case, basing their inquiry on the rumors that are current, and, if irregularities are discovered, it will take some brilliant explaining on the part of those concerned...
>
> ...The actress's baggage was properly delivered from the ship to the pier and was alphabetically arranged for anyone to lay authorized claim to. Under the law, it is held for forty-eight hours, and then, if not claimed, is turned over to the United States Appraiser, an official of the Customs, for his disposal. It was here that the break in the well-woven chain was found last Monday.
>
> Miss Empress's three pieces of baggage are not at the Cunard pier and neither are they at the Appraisers' Storehouse, 641 Washington Street, where in the event they were not delivered out of the hands of the steamship authorities, they properly should be. The Cunard officials, when interviewed, said they 'had complied with the law', which, in this case, would mean the baggage had been sent to the storehouse. That it is the only statement that would be given out. When asked if anyone else but the actress had signed for the baggage, the original statement was reiterated.
>
> These statement, one of which did not prove the other, lead to a complete investigation of the affair so far as it was possible and also brought to light that both Customs and Immigration officials are looking into the matter...

The writer then unequivocally states that many people saw Empress the night before the *Orduna* arrived in New York, which is to say, *after* she had supposedly disappeared.

> Several sailors on the ship said that Miss Empress was known to have been about the upper deck in sailor uniform and that she mingled with the crew the night before the ship made New York. This, it is

asserted, was known to many of the passengers and to the officers of the ship and that the last time she was seen in sailors' uniform was the last time she was seen at all.

The star easily could have gotten away in a dodge of this manner. Her reputation rests on her representation of male characters on the stage and it would have been no hard matter for her to have successfully impersonated a sailor, fireman, or steward...the public would be amazed of course that she should successfully have passed the inspectors of the immigration bureau, but the Inspector would not be amazed. In fact, they would be peeved, not to say highly incensed!

The article goes on to say that the State Department and Customs authorities would be justifiably angered by the hoax, and that Empress and her fellow conspirators would be surprised by the legal implications of her little publicity stunt.

The author's obvious anger underscores how certain many people were that the disappearance was a sham. The *Clipper* reporter's observation that Empress's luggage had vanished just as mysteriously as its owner is subtle but important. His point was that only two people could have claimed the luggage: a woman who could provide credentials showing she was the owner, or, alternatively, the United States Appraiser. One of the two had done so, since the bags were no longer in the custody of the *Orduna's* officers. It was known the U.S. Appraiser did not have the bags, so it followed that Empress had claimed them.

The ship's officers could have dispelled such a conclusion by telling reporters what happened to the luggage. Instead, they were evasive, saying only that they "had complied with the law." This implied to the author of the article that the *Orduna's* officers were conspirators. They had refused to answer a simple question, "Did Empress retrieve her luggage?" and by doing so, had made their earlier claim that the actress had disappeared suspect.

Why would the U.S. Government concern itself with the disappearance of Empress's luggage? Because her bags had not been checked through Customs, which was the law. If Empress had taken them, she was presumably walking around New York, undocumented by the Immigration Bureau.

THE MYSTERIOUS MISS EMPRESS

It is virtually impossible for an international traveler to slip unseen past immigration and customs checkpoints in Europe or North America today, of course. In 1919, it would have been much less difficult, but in no sense would it have been easy. Strict immigration policies had been implemented at New York piers as a result of the Great War and the Spanish Flu outbreak of 1918. The average person could not simply walk off a visiting ship and into New York, unstopped and unimpeded.

However, Empress was far from the average person. Her skills at acting and male impersonation aside, she had traveled to New York many times and could have used that experience to develop a plan to slip into the city unobserved. By 1919, the actress would have been very familiar with the layout of the piers in New York and would have known what to expect from immigration and customs officials as she disembarked. It is even possible that she knew one or more of those officials and that they were paid to assist her in her evasion. Empress was never short of cash, and bribes would not have been out of the question.

Fate conspired to help her, in any event. Though none of the reporters who accused Empress of perpetrating a hoax made note of the event, there was a longshoreman's strike in New York the very day the *Orduna* arrived, and it was causing mayhem on the docks.

<center>❦</center>

THE OCTOBER 28, 1919 EDITION OF THE *NEW YORK TIMES* chronicled the event in an article headed, "SHIP PASSENGERS UNLOAD BAGGAGE - Four Liners Arrive, but Lack of Longshoremen Causes Delay on Pier:"

> Four passenger liners arrived yesterday from French and British ports, bringing nearly 3,000 passengers...The Cunarder *Mauretania*, from South Hampton and Cherbourg, came up first, followed by the *Orduna* of the same company, from Liverpool, the French liner *Lorraine* from Havre and the White Star liner *Cedric* from Liverpool.
>
> The four liners were all made fast at their piers by 1:30 P.M., but on

account of the lack of longshoremen to handle the baggage many of the passengers did not reach their hotels before 5 or 6 o'clock, and some were still waiting for their belongings to be carried off the ships.

Army and naval officers, missionaries, bankers and actors mingled in a dense crowd with stewards, porters and other employees of the steamship lines, who were bringing the baggage off the ships and stacking it on the piers in alphabetical order...British members of Parliament were to be seen perspiring freely as they watched their trunks along the pier from the Mauretania.

If Marie Empress had indeed intended to fake her death and to sneak off the *Orduna* when it anchored in New York, she could not have wished for a better set of circumstances. Three thousand people from all walks of life and from all over the world were squeezed into a small area, tired, hot, and angry. It would have been chaos. One can only imagine the sufferings of the unfortunate immigration and customs officials who were trying to maintain control of the mob and keep tempers in check, even as they were subjected to verbal assaults by hundreds of weary travelers, many of whom were quite rich and powerful. There would have been children crying, women fainting, and men arguing, yelling, and threatening.

The American officials tasked with controlling the point of entry would have been under tremendous pressure to expedite the release of the passengers into New York and to put the entire mess behind them. Passengers and crew members who had questionable documentation or perhaps none at all may have been allowed out the gates just to keep the swarm moving. Some passengers may have found themselves moved out the gate without ever having been asked for their passport.

19

A PRETENDER TO THE THRONE

As Vaudeville calls for more or less of impersonating or character work, I wish to say a few words regarding the subject. In assuming or characterizing any personality, you must imagine yourself as being that person in body, mind and soul. Try to imagine and feel the emotions, thoughts and conclusions the real person would entertain. In a word, BE that person.

— *HOW TO ENTER VAUDEVILLE* (1913)

Some followers of the *Orduna* incident speculated that the actress had done more than fake a suicide or accidental drowning. They believed that Empress had faked her presence on the ship!

The woman that claimed to be Empress had been, according to this theory, a look-alike paid to take Empress's place. Newspapers reported this conspiracy theory without any real zeal, perhaps because they found it outlandish, but in retrospect the "Pretender" theory deserves greater consideration.

Consider, for example, a report printed in the *New York Herald*, on October 28th, just a day after Empress's disappearance:

Miss Empress was a conspicuous figure on deck because of her peculiar dress and personality. Clad completely in black, including hat, veil, stockings and shoes, she was at first believed to be in mourning. To other passengers who casually questioned her, she made evasive replies.

Here we have a report of evasive replies to casual questions while donned in an outfit that concealed almost every inch of her body, including, when the veil was lowered, her face. Note that this report was published the day after her disappearance, long before anyone suspected a hoax of any kind.

In London, reported *Variety*, it was widely believed that a bait-and-switch had occurred. "Miss Empress's name was changed," it reported. "Also, the number of the cabin she is said to have occupied while sailing to New York, disappearing before the boat arrived there."

The *New York Post* fortified this theory when it posted the following on October 29th:

Press Agent 'Lost' Marie Empress
Mystery of Actress Who Disappeared From the Orduna Is Cleared Up

Sh-h-h!

The mystery of the lost Marie Empress is solved.

Marie is as much alive as ever, but no one is supposed to know it yet. The fact is, the press agent hasn't taken the lid off yet. He doesn't want the cream skimmed from the best advertising coup ever by having a Broadway stroller greet Marie while she is still supposed to be in a watery grave at the bottom of the Atlantic. Oh no, indeed! He is going to have her properly resuscitated, so that she will land on the Palace boards in a week or two with a seaweed halo around her head and an applauding public that loves to have a new one put over on it.

The sad story of Marie, as it appeared in newspapers, was that after the Orduna left Halifax last Saturday night she sent for the stewardess and ordered dinner in her cabin. At bedtime the stewardess missed Miss Empress. She called back several times and finally reported to the purser that the vaudeville performer had disappeared. A twenty-four search of the ship had no results and the lady was

THE MYSTERIOUS MISS EMPRESS

reported as 'missing at sea.' The assumption was that she was a suicide.

"Too bad about Miss Empress," remarked a Tribune reporter yesterday to Walter J. Kingsley, of B.F. Keith's vaudeville circuit. "Where have you hidden her?"

He grinned and answered:

"Did you ever hear of a woman registering as Miss So-and-So and later changing her room and calling herself Mrs. Somebody?"

"'Ah! So that's it. Which is her hotel? Hurry! I want to find her!"

"'Wouldn't it be nice if a fishing boat picked her up off the coast or something interesting like that happened?"

"Is that what is going to happen?"

"Well, that's a story for another day. You don't expect me to give the whole show away now, do you? Don't let that fishing boat business blind you to the possibility of the lady turning up mysteriously and unannounced in New York."

It is also significant that the *Orduna's* log lists Empress as 5'7" tall. On previous manifests she was reported to be four to six inches shorter, and reporters often remarked on her petite size. Was this an error? Or was this, in fact, the height of the imposter?

In a similar vain, why did Empress identify herself as an "Artiste" which coming aboard the *Orduna*, when on all previous voyages she'd simply identified her occupation as "Actress?"

※

IF THE WOMAN ON THE *ORDUNA* WAS NOT MARIE EMPRESS, WHO WAS she, and what became of her? Perhaps the woman's actual name was Marie A. Smith, and perhaps she really was 28 years old.

One could speculate that she was an English performer whom Empress knew professionally, and perhaps personally. She had not traveled to New York before, a fact she let slip when talking to the stewardess. Though exceptionally pretty, as might be expected of a young female performer, she was not the spitting image of Empress and so

obfuscated her face on occasion with a veil and with the constant use of a monocle, which she used "conspicuously."

During the voyage, Miss Smith could have alternated between two identities. One was Marie Empress, the chipper woman-in-mourning who always wore black and used a monocle. The other was either herself, or that of a fictional character that she and Empress had developed beforehand. Regardless, the imposter needed a second public identity because passengers and crew would have noticed if one of the women getting off the ship in New York had not been seen during the crossing of the Atlantic. She would have been presumed a stowaway (or even a spy) and pulled aside for questioning.

It is one thing for a person to disappear into the ocean but quite another for a person to materialize out of it.

What became of the pretender, if this theory is believed? She could have disposed of the black dress, hat, and veil and returned to her second persona before the *Orduna* dropped anchor in New York. Then she would have simply walked off the ship and into the mists of history.

This could explain why the name in the found passport was M. A. Smith and not Marie A. Keane, and why "Professionally known as Marie Empress" was added after the owner's "real" name.

The passport holder's name was not the only oddity. A reporter claimed to have gained access to the *Orduna's* passenger logs (which had been officially turned over to the Marine Department of United States Customs) and related that they listed Marie Empress as an "actress, missing at sea, supposed suicide." The woman's passport number was listed (No. 605178) along with a comment that she had with her three pieces of baggage. She was carried on the passenger list as No. 424, her age was given as 28, and her stateroom as 480. This was all attested to by "T.M. Taylor," master of the vessel.

Much of this information is at odds with what we today find in the *Orduna's* manifest, now a public record. The manifest does indeed list Empress as a "supposed suicide," but it does not list her age as 28. The manifest lists Empress as 35 years and 7 months old. Presumably, the age the Captain put into his report came from Empress's passport and not the manifest.

Could the reporter have made an error in reporting the age listed on the incident report? Yes, but he got everything else right, to include the handwritten notation on the manifest of "supposed suicide" as well as the signature of the Captain - "T.M. Taylor," as opposed to, "T. Taylor" or "Thomas Taylor" or "Thomas T. Taylor," for example. It would be remarkable if he got such mundane details right but erroneously reported the age.

* * *

If there was an M.A. Smith standing in for Marie Empress, the passport would have been the Achilles heel of the deception, because the substitute woman would have been required to provide documentation as to her name and date of birth when applying for it. Thus, the passport was destined to include her actual name and age. The best the pretender could have done was to have "Professionally known as Marie Empress" added to the passport, a claim that would have probably required no documentation.

Why then would the manifest show a different age from the passport? Because the imposter knew that the manifest would be examined after her disappearance and that the age listed needed to be Empress's actual age.

Why didn't the individual compiling the manifest check the age in the passport against the age shown on the manifest?

Perhaps he did, and did not notice the discrepancy, focusing instead on the person's photograph and name. Even if he did observe that the ages and dates of birth didn't exactly match up, it would have been easy enough for the imposter to shrug it off as some kind of administrative mix-up.

True, most passengers who were shown a photo of Empress believed that the woman they had encountered on the ship was the woman shown in the photo. But we know today just how faulty the memories of crime witnesses are. It's also worth pondering why investigators felt the need to show the publicity photos to passengers. Why would investigators even doubt that it was Marie Empress who was missing?

Also, recall the two oddities that all aboard the *Orduna* agreed upon, which was that Empress wore not only a black dress and hat, but

also a black veil, and that she made "conspicuous" use of a monocle. If a lady wished to conceal her face, a widow's outfit, with its face-shielding veil, and a monocle, would do very nicely. With a veil and monocle, a reasonably attractive "double" could have carried out an impersonation for a week.

It is not only the passport and manifest irregularities that hint at a pretender, however. The statements made by the stewardess also suggest subterfuge. Recall that the woman calling herself Empress had told the ship's stewardess that she had never been to New York before.

"I really haven't any friends there and I don't know where I'll stay," the passenger had said.

This statement would make no sense if the woman to whom the stewardess was speaking was really Marie Empress. The English actress had spent most of her life either in New York or Los Angeles over the past decade. Empress had performed, made movies, and competed in dog shows in New York. That she did not know where to stay and had no contacts in New York was untrue.

However, were the woman *not* Empress, but a stand-in, it might very well have been her first passage to New York, and she may have indeed been looking for suggestions on where to stay and what to do.

Yes, the passenger did make reservations in New York while in Halifax, which implies she did know of at least one hotel at her destination, but by then the woman had been at sea for over a week and would have had plenty of time to query her fellow passengers for recommendations.

20

MISS X

Inspector Lestrade: They have been identified as her clothes, and it seemed to me that if the clothes were there the body would not be far off.

Sherlock Holmes: By the same brilliant reasoning, every man's body is to be found in the neighborhood of his wardrobe.

— *THE ADVENTURE OF THE NOBLE BACHELOR*,
SIR ARTHUR CONAN DOYLE

How Marie Empress disappeared from the *S.S. Orduna* is a great mystery, but who she was is perhaps a greater one.

Assume, for the moment, that the found passport was genuine and that it did not belong to an imposter, but to Empress herself. How is it possible that a woman supposedly named Marie Keane, or Kean, or Keene, or Keen, who had the stage name of Marie Empress, would have a passport issued to Marie Smith?

One explanation is that, despite her claims to the contrary, Empress really had married but had concealed her marriage for fear that it might hurt her career. She was most often cast as a vampire, and

her male audience liked to think that she was somehow available, even to them. Perhaps she feared a married vamp wouldn't sell tickets.

Here it is worth recalling that one of Empress's films, *Sybil's Scenario*, was supposedly written by an amateur: Miss Sibyl Smith. Everyone thought it odd that Knickerbocker had elected to produce a film written by a completely unknown and untested writer. Could the script in fact have been written by not by Sybil Smith, but *Marie* Smith?

Did Empress have enough clout, in terms of charisma or money, to make that happen? Perhaps. In fact, the movie made just prior to *Sybil's Scenario* was *A Lesson From Life*, which starred Empress. The name of Empress's character? Bella Keene.

Bella is the Italian word for beautiful, and Keene (using one spelling or another) was the maiden name that Empress claimed. Bella Keene was "beautiful Keene." The beautiful *Marie* Keene, that is.

That cannot be a coincidence, and it suggests that Empress did have some influence on the films which she starred.

Is it possible that she married a man by the name of Smith secretly, perhaps years ago? That would explain why she was never seen on a date, instead claiming that her dogs took up all her free time. Assuming she had wed, is it possible that Empress's secret husband had died, which is why she was wearing mourning clothes? But if so, why was she so cheerful?

To put it coldly, she would not have been the first merry widow. It may well have been a loveless union. She may have married a decade earlier and spent most of that time estranged from her spouse. Perhaps he was a good man upset by her spending all of her time on her career abroad, her flashy dresses, and her reputation as a vamp, at least on screen.

Or he may have been a terrible man, a drunk and a wife-beater, who she had left long ago. Or perhaps he and Empress met when both were far younger, married on a whim, and mutually agreed to live separate lives, parting amicably but not divorcing.

THE MYSTERIOUS MISS EMPRESS

IF EMPRESS DID STAGE HER DEATH FOR THE SAKE OF PUBLICITY, WHY would she not eventually capitalize on the stunt's success by reappearing?

There are three scenarios that might explain her continued absence.

The first is that her wish to disappear was not for the sake of publicity. Perhaps she was simply weary of performing and wanted to exit from public life as she had entered it - with a bang. Maybe she wished to take on a different persona and go in a new direction, creatively. There could be any number of reasons that she might want to be thought of as lost, even if she were alive and well.

A second scenario is that Empress had planned on using her disappearance as a publicity stunt, but upon reading articles like the one in the *Clipper* that accused her of a crime, she had decided that she would be better off dead. If so, she would have perhaps returned to England and resumed her career in vaudeville under a new name.

The third and final scenario is that something went wrong as the hoax was being perpetrated. If a boat had been hired to meet the *Orduna* and steal away Empress, it could have sunk before reaching land. Empress may have fallen into the water from the boat. The men hired to bring Empress ashore may have murdered her for the jewelry and money she brought with her onto the boat. Or, if she sneaked past Customs in New York, she may have been robbed and murdered somewhere near her hotel.

But really, the possibilities are endless.

21

FAMILY AND FRIENDS IN HIGH PLACES

Marie's claimed relationship to Sir Edmund Keane was untrue. Edmund Keane was born on March 17, 1787, the illegitimate son of an architect's clerk, Edmund Keane (the senior), and a minor actress, Ann Carey. The newborn's father committed suicide at the very young age of 22 years, having fathered no other children (or at least none that have been acknowledged). By definition, a grandniece is the daughter of one's nephew or niece, and a nephew or niece is the son or daughter of a brother or sister. Edmund Keane had no brothers or sisters.

One might object that Empress could have been the daughter of a niece or nephew to Ann Carey, but it must be remembered that Marie's last name was supposedly Keane, which clearly implies that she was tracing her roots back to Edmund, not Ann. In other words, she could only have been born a Keane, and be the grandniece of the English actor, if her father was the son of Edmund's brother. That brother being absent, she could not possibly be the grandniece.

On October 28th, the *Chicago Daily Tribune*, like so many other papers, reported on the disappearance of Marie Empress, "Noted English Music Hall Comedienne." After recounting the report of the steward that he had last seen the actress at 6:30 p.m. the night the ship

THE MYSTERIOUS MISS EMPRESS

left Halifax, the Tribune reporter provides some very remarkable personal notes about the missing woman:

> Marie Empress, was the daughter of a former Lord Mayor of London. He was prominent in Masonic circles. She was related to Edmund Keane, one of the greatest tragedians of all time. Her mother was Mme. Belchere, ranked by many critics as the peer of any great French actress. Her grandfather, Dr. Belchere, was private physician to the Rothschild family.

At first glance, this article appears to provide unusually specific information about the mysterious Empress lineage. Yet, like all other leads, the report raises more questions than it answers. It also takes us into some weird, hitherto unexplored regions.

If Empress was, in fact, the daughter of a former Lord Mayor of London, her name could not have been Empress, Keane, or Smith. There has never been a Lord Mayor Keane in London, and the most recent Smith in that capacity, prior to Empress's birth, held the office in 1817, eliminating him as her father. There has never been a man named "Empress" who served as the Lord Mayor, either.

At first glance, practically any man who served as Lord Mayor of London between 1850 and 1918 would be a potential paternal candidate, since the Tribune article, published in 1919, merely states he was a "former" Lord Mayor. Yet, the few clues available are adequate to eliminate all but a single man.

Recall that when Empress arrived in Los Angeles in 1916 and pretended to be a stranded tourist, not an actress, she carried with her a picture of the man whom she said was her father. She said he was deceased. That provides a clue - how many Lord Mayors of London from, say, 1850 to 1915 (the year of her story) were deceased in 1915?

More importantly, she said that she met King Edward in the company of her father, as a "small" girl. King Edward became King upon the death of Queen Victoria in 1901, and died in 1910.

There is but a single Lord Mayor who served during the reign of King Edward VII and who was deceased by July of 1916, when Empress told her tale: Sir Joseph Cockfield Dimsdale, 1st Baronet,

Privy Council of the United Kingdom, Knight Commander of the Royal Victorian Order, and Lord Mayor of London from 1901 to 1902, who died on August 9, 1912.

The November 9, 1901, edition of the New York Times, reported that the Lord Mayor "is a Managing Director of the banking house of Prescott, Dimsdale, Cave, Tugwell, and Co...He is a very wealthy man, and - a circumstance which is somewhat unusual with the Lord Mayors - is a favorite in London society."

This bodes well enough for Empress's paternity claim since she was traveling the world in high fashion before vaudeville or movie studios could fund such luxuries.

Empress said her father was prominent in Masonic circles - was Dimsdale?

Yes, very much so. Dimsdale was not only a member but a former Grand Warden and Grand Treasurer of the Free Masons of England.

Is it possible that Empress could have been introduced to King Edward by Dimsdale, if he were her father?

Absolutely. It was Dimsdale that carried the crystal scepter of the City of London in front of Edward VII at the King's Coronation. Empress could have been as young as 12 or 13 at that time.

These facts aside, there are reasons to doubt Empress's claim. The Lord Mayor's wife was Beatrice Dimsdale, not Mme. Belcher, and though Mrs. Dimsdale gave birth to several sons and daughters (some of whom died as infants) from 1873 to 1893, none of them were named Marie. Her father was not a French doctor employed by the Rothschilds. Her maiden name was Bower, and she was from an established English family.

Of course, it is possible that Empress was born out of wedlock to a French woman by the Lord Mayor, or that Empress was weaving truth and fiction, or fiction with more fiction, when she told others about her family. There is no readily available record of any famous French actress named "Belchere."

Were the *Los Angeles Times* and *Chicago Tribune* reporters flies caught in Marie Empress's intricate web of deception? Possibly, yet there are tantalizing hints that the actress was, in fact, somehow connected to the British aristocracy and government.

THE MYSTERIOUS MISS EMPRESS

Consider, for example, Empress's 1909 trip to the United States as a part of a New York City tour group. She came to the United States aboard the *Celtic*, First Class, arriving on September 20 and departing aboard the *Oceanic* in late November. The tourist group was not a large one, consisting of fewer than a dozen people, but the station of those few members is noteworthy.

Among them was William Edge, son of Sir Knowles Edge. At that time, he was a young man of 28, but he would soon become Sir William Edge, 1st Baronet, a British Liberal, National Liberal politician, and businessman. He was accompanied on the voyage by his brother, John.

Also in the group were George Gray Ward and his wife. Ward was one of the pioneers of trans-Atlantic cable (among his many titles, Director of the Commercial Company of Cuba, Commercial Pacific Cable Company, Mackay Companies, National Surety Company, Postal Telegraph Cable Company, U.S. and Haytl Telegraph and Cable Company, and the U.S. Mortgage and Trust Company. He was also President of the St. George's Society of New York in 1899 and 1900 and was dubbed Commander of the Order of the Rising Sun by the Emperor of Japan (per his obituary on June 16, 1922).

On the 1909 visit, Empress listed her destination as 29 Broadway, N.Y., which was the business address of A.E. Outerbridge & Co., representing the Quebec Steamship Co., Ltd., which specialized in trips to Bermuda, the Caribbean, and the West Indies. It can be no coincidence that a few months later, in July 1910, Empress would sail from London to Tenerife, Canary Islands, en route Beira, Mozambique, though during that voyage she was listed on manifest as Marie Keane.

When Empress sailed from New York to England in 1912, her name was the first on the First Class manifest, below which were the names of Lord and Lady Cavendish. It is difficult to imagine a scenario in which Empress would board the *Baltic* before the Lord and Lady unless they extended that courtesy to her.

CONNECTIONS ASIDE, IT IS WORTH CONSIDERING - AND PONDERING -

that Empress's apparent wealth did not stem from her acting career. When she arrived in the United States, the entertainer was accompanied by an entourage (or her "representatives," as they were called by newspapermen). In her many trunks were ornate and expensive dresses, and she was perpetually adorned in expensive jewelry. She owned numerous miniature show-dogs that she successfully entered into a variety of ritzy canine competitions, a pastime that would only be of interest to a woman of means and a certain level of sophistication.

The Rothchild family has for centuries been one of the wealthiest and most secretive family dynasties in the world, with dozens of palaces throughout Europe and an amassed fortune that is easily in the billions of dollars. This was as true in Empress's day as it is today and was during the Napoleonic era. In 1909, British Prime Minister Lloyd George claimed that Lord Nathan Rothschild was the most powerful man in Britain.

The Rothschild dynasty was, from its very inception, a family-affair, ensuring a reasonable degree of secrecy and solidarity. Was Empress perhaps truly connected to this famous family? Had she rebelled, seeking fame and independence, under an assumed identity? There is no evidence of this, but then again, there's not much evidence for anything in Marie Empress's life.

YET ANOTHER POSSIBILITY, THIS ONE MORE PEDESTRIAN: IN 1918, A Birmingham dentist with the surname of Taylor would claim that Marie Empress was his wife, and that the two had been married since 1902 and separated in 1906 because Marie was "infatuated" with the stage. Two years later, on November 8, 1921, almost two years after her disappearance, the *London Gazette* would publish a notice that a "Mary Ann Louisa Horton...otherwise known as Marie Empress," had died at sea.

Is it possible that Empress's maiden name was "Taylor" and married name was "Horton?"

Yes. In fact, in 1916, when sailing aboard the S.S. Baltic, Empress

did list a London point of contact as "Mrs. Taylor." This could have been Empress's mother, sister, or sister-in-law, adding plausibility to the scenario.

But there are problems with this scenario, too. For one, Empress's passport was issued to "M.A. Smith, professionally known as Marie Empress." Not "M.A. Horton" nor "M.A. Taylor."

Also, in 1919, Empress told an Orduna stewardess that she'd never married. There was no reason for Empress to lie. In fact, if the actress had so wished, she could have simply replied, "Yes," when the stewardess asked the performer if she was a widow. Empress was already, and oddly, dressed for the part. That she was a widow was what the stewardess assumed.

Additionally, each of the many times Empress sailed, she indicated on the ship's manifest that she was single. Even if she were separated in 1906, she remained legally married, and there seems no reason for her to have stated otherwise on a manifest.

If "Mrs. Taylor" was a relative, why was she identified as a friend or family member only *once* during Empress's many voyages? Taylor is not an uncommon surname, so it's quite possible Empress did know a Taylor who was not a relative.

It is noteworthy that no Taylors or Hortons ever publicly acknowledged Empress as daughter, wife, or former wife, despite her fame. That they didn't issue a single public statement acknowledging Empress as a relative during the performer's most productive years seems odd. That they remained silent as reports of her disappearance flooded newspapers is difficult to believe.

It is also strange that no one claimed Empress as a family member until just months before and after her disappearance, and that even those claims consisted of only a few words jotted down by lawyers.

If Empress wished for one last bit of obfuscation, the Taylor-Horton scenario would do very nicely.

More on this later.

22

SHIP MANIFESTS

We are fortunate that a great many ships' manifests for past centuries have been retained and digitized. They vary in content, however. At the turn of the 20th century, much less information was asked of passengers than in later years, and the information logged varied from one ship line to another.

Below, in chronological order, is the information that is available for Marie Empress's numerous trips from 1907 to 1919. The dates provided are typically the dates of arrival at destination ports, though on occasion they are dates of departure (the date of arrival not being provided).

Note, in particular, how her place of birth, age, and height change from year to year.

 S.S. Carisbrook Castle
 21-Dec-07
 From: Durban (Cape Town)
 To: Southhampton
 Profession: Actress

S.S. Celtic
 20-Sep-09
 From: Liverpool
 To: NY
 Age: 23
 Place of Birth: Paris, France
 Marital Status: Single
 Point of Contact: Dr. Kingdon (London)
 Profession: Actress
 Where Staying: 29 Broadway, New York
 Description: 5'5", brown eyes, dark complexion

S.S. Oceanic
 1-Dec-09
 From: New York
 To: Plymouth
 Marital Status: Single

S.S. Ingeli
 20-Jul-10
 From: London
 To: Canary Islands
 (Used the name Marie Keane)

S.S. Inanda
 18-Aug-10
 From: Beira, Mozambique
 To: London

SAMUEL FORT

(Used the name Marie Keane)

S.S. St. Paul
25-Jan-11
From: Southampton
To: New York
Age: 22
Place of Birth: United States? (unclear)
Where Staying: 1931 17th (or 19th) Street, Washington, D.C.

S.S. Baltic
30-Nov-12
From: New York
To: Liverpool
Age: 24
Point of Contact: D. Lynch (London)

S.S. Campania
30-Dec-12
From: Liverpool
To: New York
Age: 25
Place of Birth: Paris, France
Marital Status: Single
Profession: Actress
Point of Contract: Dr. Kingdon (London)
Description: 5'6" tall

S.S. Caronia
2-Jun-13
From: Liverpool
To: New York
Age: 25
Place of Birth: Paris, France

Marital Status: Single
Profession: Actress
Point of Contract: Dr. Kingdon (London)
Description: 5'2" tall

S.S. Baltic
25-Oct-16
From: Liverpool
To: New York
Age: 33
Place of Birth: Birmingham, England
Marital Status: Single
Profession: Actress
Point of Contact: Mrs. Taylor (London)

S.S. Lapland
9-oct-17
From: New York
To: Liverpool
Age: 33
Profession: Actress
Country of Future Permanent Residence: United States

S.S. Orduna
27-Oct-19
From: Liverpool
To: New York
Age: 35
Place of Birth: Birmingham
Marital Status: Single
Profession: "Artiste"
Point of Contact: Mr. Oliver Williams (London)
Description: 5'7" tall, black hair, brown eyes

23
UNUSUAL CONTACTS

E mpress sailed from England to the United States on at least six occasions (probably more), and the manifests for those voyages still exist in digital form. They reveal to us something which must be significant, though it is unclear in what way: She never *appears* to have listed a family member as a point of contact (at least not anyone by the name of Keane, Keene, Smith, or, of course, Empress). Instead, she provided the names of the following individuals, some only once, and some multiple times:

- Dr. Kingdon, 160 Goldhawk Rd, London, in 1909, 1912, and 1913
- D. Lynch of 45 Bedford Square London in 1912
- Mrs. Taylor, 31 Lynmouth Rd, East Finchley, in 1916
- Oliver Williams, 116 Victoria Street, London in 1919

OLIVER WILLIAMS

Oliver Williams was the Secretary for numerous organizations, to include the Lucas-Tooth Boys Training Fund, the English Public-House Trust Association, the Colonial Troops Entertainment Committee, and many others.

The address Empress had provided for him, 116 Victoria Street, London, was probably William's office, not his residence, and the organizations he was involved in suggests that Williams was either employed directly by the British Government or in some other way represented its interests.

Williams had authored a book edited by Countess Howe, formerly Lady Emily Mary Curzon-Howe, and wife Sir Robert Nigel Fitzhardinge Kingscote.

Dr. Kingdom

Dr. Kingdon, Empress's 1909 and 1913 contact, was Wilfred Robert Kingdon, born in or around 1872. According to the 1913 Medical Register, the doctor had graduated from the University of Durham and had credentials as a Bachelor of Medicine (1895) and a Bachelor of Surgery (1897).

As of 1897, he was listed as a member of the Medico-Psychological Association of Great Britain and Ireland in the Journal of mental science, volume 54. The British Medical Journal, Volume 2, reported that he had been appointed Assistant Medical Officer to the City Asylum, Birmingham in July of 1896, an, in 1918, that he had assumed the role of "Captain Wilfred Kingdon, R.A.M.C. (Royal Army Medical Corps)" and "honorary secretary."

His obituary, in the April 11, 1942 edition of the British Medical Journal, stated Kingdon had been a medical officer to Ticehurst Asylum (a "madhouse for the rich"), and mental specialist to the Royal Victoria Military Hospital, Netley, and the Lord Derby War Hospital, Warrington. He was also a lecturer and examiner for the British Red Cross Society. Like Williams, Kingdon was a gentleman who had achieved great professional success.

Dr. Lynch

D. Lynch was Dr. Gilbert Lynch. M.D., a member of the Royal

College of Surgeons and a Fellow of the Obstetrical Society of London, and a graduate of Trinity College. He was born in 1852 in Dublin, Ireland and admitted to the Royal College of Surgeons of England in 1883.

According to the London-based *Hospital Gazette* and *Student's Journal*, Dr. Lynch was sued for divorce by his first wife, Adelaide, in 1885. By 1901, Lynch, age 48, was living with his second wife, Lavina, age 34, and son John, age 6. Dr. Lynch died on November 26, 1918, approximately one year before Empress disappeared from the *Orduna*.

Mrs. Taylor

Mrs. Taylor, the point of contact provided in 1916, was said to live at 31 Lynmouth Rd, East Finchley. The fog of history conceals the identity Mrs. Taylor. All that can discerned from the public record is that in 1915, 31 Lynmouth Road was the home of Thomas Louis Healy, who appears to have been an electrical engineer. His name appears in both the *Journal of the Institution of Electrical Engineers*, 1903, and the *List of Officers and Members of the Institution of Electrical Engineers* in 1915. The identity of Mrs. Taylor, or her husband, and whether either had any connection to Thomas Healy, is unknown. If one believes that Empress's maiden name was Taylor, it's possible that the woman was her mother, sister, or sister-in-law; that is not indicated on the ship manifest, however. It is curious, too, that Mrs. Taylor appears on only one manifest despite Empress's numerous trips across the Atlantic.

There must be something to be discerned from this eclectic list of contacts. Two, for example, were physicians. Did Empress have a secret medical condition that necessitated the use of physicians as points of contact?

At least three (Oliver, Kingdon, and Lynch) were highly educated professionals. Perhaps Mrs. Taylor was, also, but that's not certain.

This suggests that Empress's social circle included persons of intellect with families who had the means to send their sons to good schools.

And what are we to make of Dr. Kingdon, medical officer to Ticehurst Asylum, "madhouse for the rich?" Did Empress have mental issues? If so, she was being attended to by an institute that catered to the rich - which she was, presumably, though where her money came from is unclear. She was, recall, already well-financed when she landed in New York and frequently attended glitzy dog shows. Her few films and stage performances would not have added significantly to the money she seems to have already had.

Here one is led to ponder her possible connections to British aristocracy, or the Rothschild family, or a rich Masonic father.

Remember that while these ship manifests are today publicly available, when Empress provided her points of contact, they were seen only by ships' officers. Did she not have a single family member she could list as a contact? If she did, she was going to extraordinary lengths to conceal her family's identity by omitting family names from even the documents hidden from the eyes of the public.

24

MISS NOBODY

It is also necessary to have a good finish, as if you have, you will find the audience will show their appreciation and call you back again for an encore.

— HOW TO ENTER VAUDEVILLE (1913)

So, here we are. Marie Empress, also known as Marie A. Keane and Marie Smith, and possibly still other names, who was born in England and France and the United States on five different dates, who was a child and an adult, a woman and a man, who either committed suicide or didn't, has ultimately fooled us all. She was a mystery in life, and she is a mystery in death. She disappeared from a place and at a time that should have been made such a disappearance almost impossible. Then she performed the most amazing disappearing act of all - she disappeared from history.

Once, she was a star. Once, she was a singer, a dancer, a comedienne, an impersonator, and an actress. Once, she was admired for her beauty and famous for her jewelry and was loved by the camera. Once, her name alone was enough to pull ticket-buyers into a theater.

THE MYSTERIOUS MISS EMPRESS

Today, she is forgotten. Her name appears in a few movie databases and necrologies, but the entries that follow her name are short and often inaccurate. Typically, no more than a few words are written about her in even the most comprehensive Hollywood history books.

While I have attempted to chronicle all of Empress's films, there are probably a few that were not released, or not advertised, or which have been lost to time for reasons unknown.

The December 13, 1919 edition of *Motion Picture News* reported that a director by the name of Harry Revier had spent "many fruitful years in London and Paris," and that "His work as a director of Petrova, Edmund Breese, Dorothy Green and Marie Empress has been attested in some of the best pictures of their several careers." Yet none of Empress's known movies list Revier as director, and none of Revier's known movies lists her as a player.

Revier is perhaps best known today as the director of two Tarzan movies, but he also remembered as an "exploitation" director, at least during his later years, on par with the infamous Ed Wood.

An independent, pioneering director who was beholden to no studio, Revier made his first film in 1914, which does indeed make him a contemporary of Empress. In fact, he is known to have made at least seven films between 1914 and 1920, and many others after that. Interestingly, the Los Angeles barn in which Cecil B. DeMille, Sam Goldfish (Goldwyn), and Jesse Lasky filmed the Squaw Man was leased from Harry Revier and his partner L.L. Burns.

It is entirely plausible that Revier would come into contact with Empress either through Lasky and his partners, or in some other manner, while Empress was making films in California. Empress was a relatively independent actress who, like Revier, was not committed to any one studio, and would have probably been open to appearing in one of the director's photoplays.

It is noteworthy that Reiner also claimed (correctly) to have directed "Petrova, Edmund Breese, (and) Dorothy Green." Olga Petrova, it will be recalled, was an Englishwoman whose real name was Muriel Harding. Harding, as Petrova, had appeared at the Folies Berger, as had, perhaps, Marie Empress, while it was operated by Lasky

131

and Harris. The film which Revier was alluding to was the 1916 5-reeler "The Eternal Question" (Popular Plays and Players/Metro).

In fact, it was Revier and his partner, L.L. Burns who had provided Jesse. L. Lasky and Cecil B. DeMille a "headquarters" (actually a marginally upgraded barn) when the two production men arrived in Hollywood.

There is also a single reference, in the *Syracuse Herald*, to an "upcoming" Empress movie titled *The Retribution of a Woman's Honor*, which the newspaper claimed would be released in July of 1916. Yet there is no record of the film. If it was released, it was not well advertised and must have had a very short run.

While Marie Empress's final public appearance on the silver screen occurred in the Balboa photoplay, *What A Girl Doesn't Know*, that was not Empress's last appearance in front of a motion picture camera.

In 1918, the state of Pennsylvania published the *Pennsylvania State Board of Censors List of Films, Reels and Views Examined*, which was a huge list of all films that the motion picture industry had submitted to the state for review prior to distribution to theaters. This was standard practice at the time. Without approval of a state board, a film could not be shown in a state. Films listed were either *approved* or *modified*, i.e., something had been edited out to make the movie suitable for public consumption.

Buried deep within this forgotten tome, on page 277, is the listing for a film titled simply *Miss Marie Empress*. Column two, right of the title, is supposed to contain the name of a motion picture's manufacturer. Yet, unique among the thousands of films listed, for *Miss Marie Empress* the only entry is "Unknown."

Column three, *For Whom Reviewed*, was used to list the name of the film's motion picture studio, such as Pathe, Famous, General, or Metro. But for this particular film only a name is given: *Marie Empress*.

The film's length is listed as one reel. It was approved by the state on June 25, 1917.

The universe works in mysterious ways. As proof, one need only consider the names of the two films between which the final film of Miss Marie Empress was placed in the Pennsylvania list.

THE MYSTERIOUS MISS EMPRESS

Listed above Empress's film is a Vitagraph movie titled, *Miss Jekyll and Madam Hyde*.

Below it is a Pathe motion picture.

Miss Nobody.

25

THE CURTAIN LIFTED

What happened the evening Marie Empress disappeared is a mystery which will probably never be solved. But another mystery *has* been solved. Empress's identity.

❦

A FEW YEARS AGO, I PUBLISHED A DETAILED HISTORY OF AN OBSCURE California cult that called itself "The Divine Order of the Royal Arms of the Great Eleven." I spent eight years researching that book to ensure it was as comprehensive as possible – to the point that one reviewer characterized it as "encyclopedic."

Nevertheless, the current edition of *Cult of the Great Eleven* is twice the size of the first, an increase which is mainly attributable to the incorporation of information provided me by local historians and relatives of cult members or victims after the first edition was printed.

I've had the same good fortune with *The Mysterious Miss Empress*. Only months after I published the first edition, and within just days of the hundredth anniversary of Empress's disappearance at sea, I was

contacted by Ms. Janice Llewellyn. Ms. Llewellyn informed me that Empress was "a bit of a legend" in her family. Not only did she know who Empress was, she had a letter written by the actress in 1917, addressed to Ms. Llewellyn's aunt!

Ms. Llewellyn was kind enough to send me a scanned version of the letter, in addition to some notes from her own research. She believes the letter was written sometime in the autumn of 1917 and was sent from Piccadilly mansions on Shaftesbury Avenue, in London. I have no doubt that the letter was written by Empress, since the author's writing style exactly matches the writing on the back of a publicity photo, which I own, and which was signed by Empress.

The letter reads:

Dear Aunt Jess,

Was up at mother's yesterday and she gave me your address so I could write. She tells me how well & young you look- also what a fine family you have. If I had arrived a few weeks earlier I should have seen you eh? How long my stay is going to be over here I do not know- but I don't think long. I'm afraid I should never be able to stand the damp English climate & the cold rooms after being so used to America. Anyway I was horribly homesick to see the family & to know how all were- now I shall return & feel more contented to settle to my work-

Three or four of my pictures are being imported this month or next-

The names are -

Sibyl's scenario

The Woman Redeemed

The Chorus Girl & the Kid

The Siren of the Slums

They would have been here before but the duty is so terribly heavy on them. It just breaks my heart to see the country in the state it is in & our wonderful boys so wounded: I wonder if I shall ever be in Wales to see you all? Fancy seven thousand 500 miles I travelled from the Pacific coast to have a talk to the folks. Now all kind wishes and thoughts to you & all your dear ones.

Your affectionate niece

Marie.

SAMUEL FORT

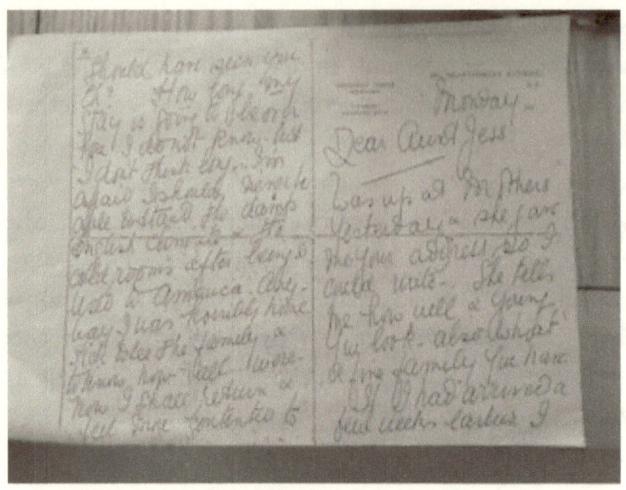

Page 1 of Marie Empress's letter, circa 1917

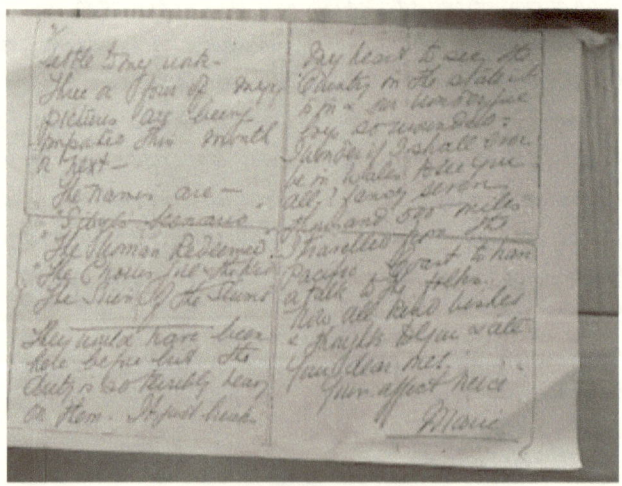

Page 2 of Marie Empress's letter

Ms. Llewellyn added that Marie Empress was born *Mary Ann Louisa Taylor*, in 1884. She was the daughter of John Taylor and Louisa Blews of 152 Broad Street, Birmingham, and was the eldest of four children, with three sisters and a brother.

Mary's father was a painter and house decorator. He was quite successful, leaving behind the hefty sum of 6,000 pounds when he died in 1901.

THE MYSTERIOUS MISS EMPRESS

The following year, in 1902, Mary (Marie) married William Herbert Horton, who, in 1901, was a clerk in a hosiery department (a "drape buyer"). The marriage was ill-fated. Within just a few years, Empress would embark upon her worldwide tour as a vaudevillian. She would, in the decade that followed, publicly deny she was ever married, though her husband did not sue for divorce until just before her disappearance.

We now know that the "Mrs. Taylor" whom Empress listed as a contact when traveling in 1916 was, almost certainly, Empress's mother.

And Dr. Oliver? He apparently had connections with entertainment studios in England. Recall that he was the Secretary for the Colonial Troops Entertainment Committee. A logical conclusion is that Empress entertained British troops during the Great War.

The nature of her relationship with Dr. Kingdon and Dr. Lynch has not, to my knowledge, been established.

IT REMAINS UNCLEAR WHY EMPRESS WAS SO INTENT ON HIDING HER actual identity, to the extent that she even fabricated a "real" surname of Keane. Was it because she believed an imaginary relationship to Edmund Keane bolstered her credentials? Or was she attempting to conceal a failed marriage in order to maintain her public allure as a vampire woman? Or did she simply relish her private life to the point that she would go to much greater lengths to keep it private than did other entertainers of her era?

The letter written by Empress gives us our only insight into the woman's private world. Her distress at the injury the Great War has caused her country and its fighting men is plain. She longs for sunny and warm California, some 1,500 miles distant, which was physically untouched by the Great War, and which might as well have been another world. She remains vested in her career, proudly listing her most recent films and lamenting the fact that they hadn't yet been imported to England.

She comes across as a woman who recognizes the bleakness around

her but is who was not cowed by it. She remains firmly attached to her dreams and looks forward to better days.

Whether she lived to see those better days, we cannot say with certainty.

AFTERWORD

My hope is that this short history of the enigmatic actress known as Marie Empress will spur further interest and consequently additional research into the mysterious woman's life and films. It is almost beyond hope that any of her films will ever be discovered, yet there are certainly photographs, interviews, and perhaps even a few movie posters out there, somewhere, neglected and ignored, waiting to be found. This beautiful English entertainer presents us with a real-life Hollywood-style mystery. Who doesn't love a good mystery?

If nothing else, I hope this book serves as a memorial to a once-famous performer. Marie Empress was presumed lost at sea and, so far as I am aware, there is no gravestone to mark her arrival or departure from this mortal plane.

I would like to publicly extend my heartfelt gratitude to Ms. Janice Llewellyn for definitively establishing Marie Empress's true identity, and for providing, for publication, the actress's letter to her aunt. Without Ms. Llewellyn's efforts, the public might have been forever tangled in Empress's intricate web of playful deceit. That the actress's ruse lasted so long remains a monument to Empress's ingenuity.

AFTERWORD

In closing, I will provide a wishful but endearing solution to the Marie Empress mystery, promoted by a Canadian writer.

In December 1919, the *Manitoba Free Press* told its readers that Empress was not aboard the *Orduna* when it arrived in New York. In fact, it claimed, Empress never left Halifax.

In the article, W*EDS A STEVEDORE* - *Popular English Actress Was Not Lost Off Steamer Orduna*, unidentified persons claim to have see Empress come ashore in Halifax "with matrimony in her eye."

> Dispensing with preliminaries, she, they say, made the acquaintance of a stevedore on the Halifax waterfront, and to him she put the question: How would he like to marry her? The stevedore showed traces of hesitancy. The question was rather abrupt. He had not considered the matter very seriously, he countered, and was really not in just the financial circumstances necessary to a successful 'pull' in 'double harness.' That did not worry the heroine the least little bit. Money! What was money? A mere pawn in the game. She had (in language more expressive than elegant) 'slathers of it'.
>
> Another convert to orange blossoms was made, the story runs, and he hastened home, packed his belongings, rejoined the prospective bride, and Miss Marie Empress and her stevedore turned their faces toward the setting sun and did a sort of movie 'fade out'.

※

If ever a movie was made about the life of Marie Empress, this would indeed be the happy ending demanded by her fans.

<div style="text-align:right">
Sam Fort

November 12, 2019
</div>

MARIE EMPRESS FILM CHRONOLOGY

Old Dutch
 Released: February 1915
 Character: Mildred Bennett
 Director: Frank Crane
 Reels: 5
 Producer: Shubert Films Corporation
 Distributor: World Films Corporation
 Notes: None

When We Were Twenty One
 Released: April 1915
 Character: The Firefly
 Director: Hugh Ford/Edwin S. Porter
 Reels: 5
 Producer: Famous Players Corporation
 Distributor: Paramount Pictures Corporation
 Notes: None

The Stubbornness of Geraldine
 Released: October 1915

MARIE EMPRESS FILM CHRONOLOGY

 Character: Geraldine (?)
 Director: Gaston Mervale
 Reels: 5
 Producer: Art Film
 Distributor: States Rights (?)
 Notes: None

The Woman Pays
 Released: November 1915
 Character: Mrs. Connie Beverly
 Director: Edgar Jones
 Reels: 5
 Producer: Columbia
 Distributor: Metro Pictures Corporation
 Notes: None

Behind Closed Doors
 Released: January 1916
 Character: Inez Valenti
 Director: Joseph A. Golden
 Reels: 5
 Producer: Triumph Film Corporation/Equitable Motion Picture Corporation
 Distributor: World Film Corporation
 Notes: Also released under the titles "Love's Crossroads," "Love's Cross Trail," and "The Guilty Woman"

The Grip of Evil
 Released: July of 1916 thru December of 1916
 Character: The Heavy
 Director: W.A.S. Dougley, Louis Tracey
 Reels: 28 (14 x 2-reels per scenario)
 Producer: Balboa
 Distributor: Pathe Frere (Melies)
 Notes: A series of short films

MARIE EMPRESS FILM CHRONOLOGY

Sybil's Scenario
 Released: August 1916
 Character: Either the mother or the abducted dancer
 Director: H.M. Horkheimer
 Reels: 3
 Producer: Knickerbocker Star Features
 Distributor: Pathe Frere (Melies)
 Notes: None

A Lesson From Life
 Released: September 1916
 Character: A Young Writer (Belle Keene)
 Director: H.M. Horkheimer (?)
 Reels: 3
 Producer: Knickerbocker Star Features
 Distributor: Pathe Frere (Melies)
 Notes: Frank Mayo and Reaves Eason Jr. were also cast members. Also known as "The Siren of the Slum"

The Chorus Girl and the Kid
 Released: November 1916
 Character: The Chorus Girl (Mary Jones)
 Director: ?
 Reels: 3
 Producer: Knickerbocker Star Features
 Distributor: Pathe Frere (Melies)
 Notes: The "kid" was played by Virginia Corbin

Woman Redeemed
 Released: Planned for December 1916
 Character: ?
 Director: ?
 Reels: ?
 Producer: B.S. Moss Motion Picture Corporation
 Distributor: Pathe Frere (Melies)
 Notes: No reviews; unclear what happened to this film.

MARIE EMPRESS FILM CHRONOLOGY

The Girl Who Doesn't Know
 Released: December 1916
 Character: Zelma
 Director: Charless Bartlett
 Reels: 5
 Producer: B.S. Moss Motion Picture Corporation
 Distributor: States Rights
 Notes: None

In the Hands of the Law
 Released: February 1917
 Character: ?
 Director: Eason B. Reeves or Ben Goetz
 Reels: ?
 Producer: B.S. Moss Motion Picture Corporation
 Distributor: Balboa
 Notes: None

Miss Marie Empress
 Released: not released
 Character: Marie Empress as herself
 Director: ?
 Reels: 1
 Producer: ?
 Distributor: ?
 Notes: Perhaps an audition film?

www.ingramcontent.com/pod-product-compliance
Lightning Source LLC
Chambersburg PA
CBHW021819170526
45157CB00007B/2650